A Small Nation *of* People

T0089636

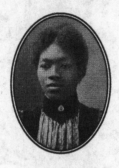

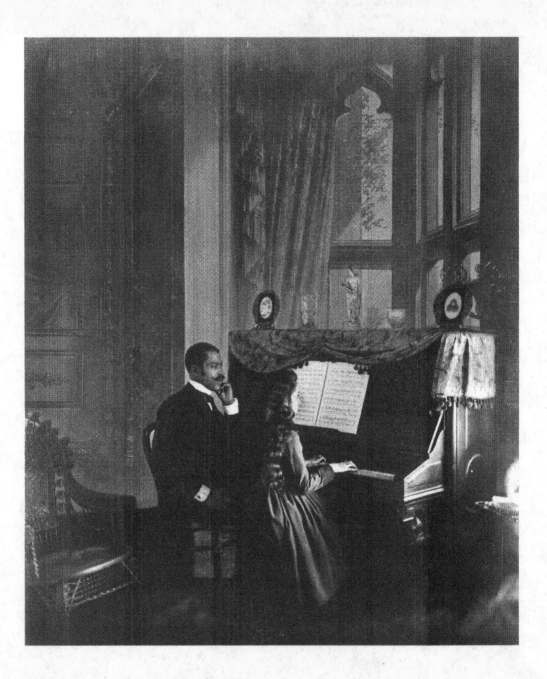

A SMALL NATION *of* PEOPLE

W. E. B. DU BOIS AND AFRICAN AMERICAN PORTRAITS OF PROGRESS

THE LIBRARY OF CONGRESS

with essays by

David Levering Lewis and Deborah Willis

Amistad

An Imprint of HarperCollins*Publishers*

A SMALL NATION OF PEOPLE. Copyright © 2003 by the Library of Congress. "A Small Nation of People: W. E. B. Du Bois and Black Americans at the Turn of the Twentieth Century" copyright © 2003 by David Levering Lewis. "The Sociologist's Eye: W. E. B. Du Bois and the Paris Exposition" copyright © 2003 by Deborah Willis. All rights reserved. Printed in the United States of America. No part of this book may be used or reproduced in any manner whatsoever without written permission except in the case of brief quotations embodied in critical articles and reviews. For information, address HarperCollins Publishers, 195 Broadway, New York, NY 10007.

HarperCollins books may be purchased for educational, business, or sales promotional use. For information, please e-mail the Special Markets Department at SPsales@harpercollins.com.

Designed by Laura Lindgren

LIBRARY OF CONGRESS EDITORIAL TEAM
W. Ralph Eubanks, *Director of Publishing*
Linda Barrett Osborne, *Editor*
Vincent Virga, *Picture Editor*
Nicholas Osborne, *Researcher*

The Library of Congress has cataloged the hardcover edition as follows:
A small nation of people : W. E. B. Du Bois and African American portraits of progress / The Library of Congress ; with essays by David Levering Lewis and Deborah Willis.—1st ed.
 p. cm.
 Includes 150 of the photographs that W. E. B. Du Bois included in his display on African Americans in Georgia exhibited at the 1900 Paris Exposition. These photographs are part of the Daniel Murray Collection at the Library of Congress.
 Includes bibliographical references.
 Contents: A small nation of people : W. E. B. Du Bois and Black Americans at the turn of the twentieth century / by David Levering Lewis—The sociologist's eye: W. E. B. Du Bois and the Paris Exposition / by Deborah Willis—Photographs.
 ISBN 0-06-52342-5
 1. African Americans—Social conditions—To 1964—Pictorial works. 2. African Americans—Georgia—Social conditions—20th century—Pictorial works. 3. African Americans—Georgia—Portraits. 4. Du Bois, W. E. B. (William Edward Burghardt), 1868–1963. 5. Exposition universelle internationale de 1900 (Paris, France) I. Lewis, David L., 1936– II. Willis, Deborah, 1948– III. Library of Congress. IV. Daniel Murray Collection (Library of Congress)
E185.86S6325 2003
305.896'073'009034022—dc21 2003044440

ISBN: 978-0-06-081756-5 (pbk.)
ISBN-10: 0-06-081756-9

22 23 24 25 26 LBC 12 11 10 9 8

FRONTISPIECE (PLATE 1): African American man giving a piano lesson to young African American woman, Georgia.

HB 09.12.2022 1243

For the unnamed women, men, and children whose portraits are included in this book, who defied prejudice and racism by proudly posing for these photographs, bequeathing us a true picture of the beauty and courage of African Americans.

"...an honest, straightforward exhibit of a
small nation of people, picturing their life and development
without apology or gloss, and above all made by themselves...."

—W. E. B. DU BOIS

CONTENTS

PREFACE

❧

"The true test of the progress of a people is to be found in their literature," Daniel Alexander Payne Murray, the Assistant Librarian of Congress, wrote more than one hundred years ago. His untiring efforts to compile a collection of works by African Americans, which would otherwise have been lost, vastly enriched the holdings of the nation's Library. Among the treasures Murray brought to the Library of Congress were books, pamphlets, and photographs displayed as part of the American Negro Exhibit at the 1900 Paris Exposition. Murray collaborated with Thomas Calloway, a lawyer, educator, and organizer of the exhibit, and W. E. B. Du Bois, then a sociology professor at Atlanta University, who concentrated on a study of Georgia, to assemble this compelling testament to the accomplishments of black Americans since Emancipation.

The American Negro Exhibit included some five hundred photographs of people, homes, churches, businesses, and landscapes that captured the lives and communities of African Americans at the turn of the twentieth century. One hundred and fifty of these photos are featured in this book. Although a few have been published before, this is the first time that a significant number of these images are brought together in a single volume. The essays by noted scholars David Levering Lewis and Deborah Willis shed new light on pivotal events in American history and the history of black photography that provide the context for the choice of these photographs in 1900 and their importance today.

The Paris Exposition photographs form part of Murray's legacy to the Library of Congress, an institution he served for fifty-two years. Born to freed slaves, he had little formal education when he became a personal assistant to Librarian of Congress Ainsworth Spofford in 1871. He soon mastered several foreign languages and was a remarkable researcher. These skills led to his appointment as Assistant Librarian in just ten years icated himself to searching for works by black authors and compiling an impressive bibliography. He built the Library's collection of books and other written materials demonstrating the achievements of African Americans. At his death in 1925, he also bequeathed his personal library of nearly fifteen hundred volumes to the Library. In his life and work, Daniel Murray embodied the spirit of the institution he loved as a seeker and disseminator of knowledge.

Today the Library of Congress—which holds more than 126 million items, most of them housed in three buildings on Capitol Hill—continues to serve the legislators of the United States and the public, as Murray did. Each day we add new material to the Library's website (www.loc.gov) in an effort to make our resources available to people around the world. All of the 1900 Paris Exposition photographs that Murray brought to the Library can be accessed online along with thousands of images, manuscripts, and other items related to the experience of African Americans. There is no more fitting tribute to Murray—and to W. E. B. Du Bois and Thomas Calloway, and to all who contributed to the American Negro Exhibit—than that their work should be remembered, honored, and celebrated.

JAMES H. BILLINGTON
Librarian of Congress

INTRODUCTION

Oɴ Dᴇᴄᴇᴍʙᴇʀ 28, 1899, W. E. B. Du Bois began work on a display for the Exposition des Nègres d'Amérique—the Exhibit of American Negroes—at the Paris Exposition. As a rising star in the new field of sociology, Du Bois focused on a set of charts, maps, and graphs recording the growth of population, economic power, and literacy among African Americans in Georgia. But he also included photographs of what he called "typical Negro faces," homes, businesses, churches, and communities that defied the image of blacks as impoverished, lazy, and ignorant—stereotypes held by many white Americans. Above all, the photographs Du Bois chose exemplified dignity, accomplishment, and progress. He presented his compelling vision of people of color at a grand and sweeping world's fair that attracted more than 50 million visitors from its opening day on April 14, 1900, to its close some six months later in November.

France had held international expositions since 1855, but the 1900 Paris Exposition was the most ambitious. It heralded the arrival of a new century, as it also celebrated the nineteenth century's belief in progress, scientific accomplishments, and commercial and economic success. Country after country lined up to showcase its cultural and industrial achievements on some three hundred fifty acres bordered by Parisian landmarks: the Champs-Elysées, Hôtel des Invalides, Champ de Mars, and the Trocadéro. On the magnificent Rue des Nations

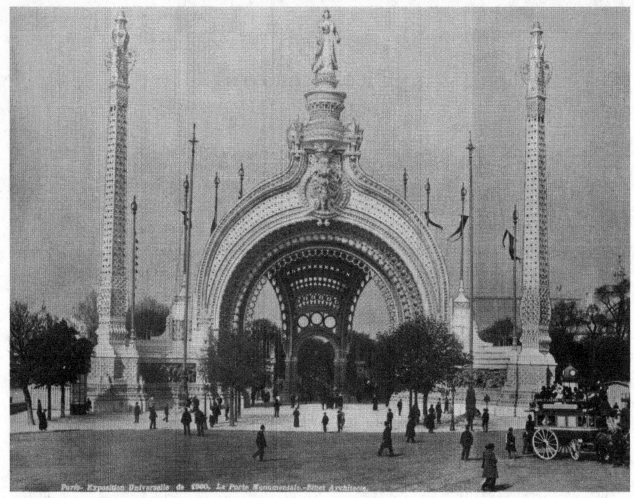

Paris- Exposition Universelle de 1900. La Porte Monumentale.-Binet Architecte.

2. Monumental Portal, entrance to Paris Exposition, 1900.

along the River Seine, the United States pavilion sat between those of Turkey and Austria—a last-minute concession by the French to move the Americans into the first rank of nations. The United States erected separate pavilions for displays of agriculture, forestry, printing, and publishing, as well as one featuring the products of the McCormick Harvester Company and another, the manufacture of American bicycles.

These attractions competed with a host of technological and architectural wonders: a state-of-the-art moving sidewalk, the world's largest telescope and globe, a giant champagne bottle that contained a small theater, and an elevator ride up the Eiffel Tower—which had been erected for the 1889 Exposition and was now newly painted a golden shade of yellow. Nor were Europe's colonial interests unrepresented. There were displays from South Africa, Indonesia, and the Portuguese empire, and large pavilions for the French conquests of Indochina, Senegal, Cambodia, Tunisia, and Algeria. Although western Europe and the United States spoke of universal advancement and unity, they perceived Asia and Africa as primitive and exotic—and second-class. In fact, when the United States first planned its exhibits, financed by Congress with appropriations of $1.25 million, African Americans were accorded no place at all.

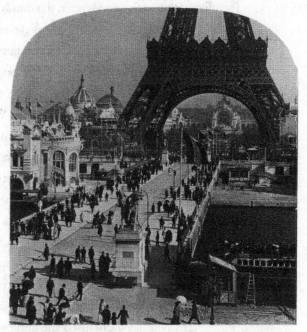

3. The Eiffel Tower with the Champs de Mars in the distance, Paris Exposition, 1900.

It was Thomas Calloway, an African American lawyer and educator, who called for black participation. Calloway had served as a state commissioner for the 1895 Atlanta Exposition, which brought widespread attention to black Americans. He understood that the new world's fair in Paris was an opportunity to demonstrate African American progress and accomplishments to an even larger audience. He sent a letter to "over one hundred representative Negroes in various sections of the United States," including Booker T. Washington, the head of Tuskegee Institute, and activist and clubwoman Mary Church Terrell. "To the Paris Exposition . . . thousands upon thousands will go," he argued, "and a well selected and prepared exhibit, representing the Negro's development in his churches, his schools, his homes, his farms, his stores, his professions and pursuits in general will attract attention as did the exhibits at the Atlanta and Nashville Expositions, and do a great and lasting good in convincing thinking people of the possibilities of the Negro."

The recipients of his letter agreed. Washington himself appealed personally to President William McKinley, and just four months before the opening of the Exposition, Congress belatedly appropriated fifteen thousand dollars to fund an exhibit "of the educational and industrial progress of the negro race in the United States." Calloway was appointed special agent and turned to his friend and former classmate at Fisk University, W. E. B. Du Bois, for help. A professor of sociology at Atlanta University, Du Bois had studied at the University of Berlin and held degrees from Fisk and Harvard. He had already distinguished himself by publishing *The Suppression of the African Slave Trade to the United States of America, 1638–1870*, the very first title Harvard chose to publish in its Historical Monograph Series. He had also published *The Philadelphia Negro*, a highly praised sociological study.

Du Bois likely discussed the purpose of the exhibit with Calloway, who later wrote their intention was "to show ten things concerning the negroes in America since their eman-

cipation: (1) Something of the negro's history; (2) education of the race; (3) effects of education upon illiteracy; (4) effects of education upon occupation; (5) effects of education upon property; (6) the negro's mental development as shown by the books, high class pamphlets, newspapers, and other periodicals written or edited by members of the race; (7) his mechanical genius as shown by patents granted to American negroes; (8) business and industrial development in general; (9) what the negro is doing for himself through his own separate church organizations, particularly in the work of education; (10) a general sociological study of the racial conditions in the United States."

Calloway enlisted Daniel A. P. Murray, Assistant to the Librarian of Congress, to assemble the written material, including a bibliography of 1,400 titles, 200 books, and many of the 150 periodicals published by black Americans. Du Bois was given twenty-five hundred dollars and "ten or a dozen clerks" to "undertake the special investigation of Georgia, which he had requested to make. The State of Georgia was chosen because it had the largest negro population and because it is a leader in Southern sentiment," Calloway wrote.

The American Negro Exhibit was not displayed in the United States "national building," but in the Palace of Social Economy and Congresses. It shared a small space with maps detailing U.S. resources, models of New York City tenements, and information on libraries, railroad pensions, and labor unions. A variety of countries presented information on child labor, workmen's cooperative associations, agricultural credit, the moral and intellectual condition of workmen, and hygiene. The displays featured Hungarian farmers, artists, and peasants at work; housing for workers in Holland; and a full-size model of a teahouse erected by Russian temperance societies. One hundred twenty-seven international congresses also met in the building, considering everything from postal regulations, copyright, and stamp and coin collecting to ornithology and fisheries to hypnotism, public health, and fencing.

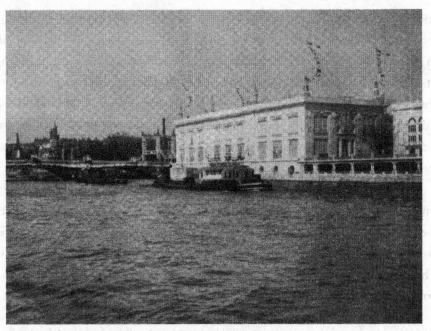

4. Palace of Social Economy and Congresses, Paris Exposition, 1900.

Here then, with other exhibits of society's progress, were the photographs, charts, artifacts, and books assembled for the American Negro Exhibit—what Du Bois called "an honest, straightforward exhibit of a small nation of people, picturing their life and development without apology or gloss, and above all made by themselves." Many of the portraits he selected of African Americans from Georgia—children, men, and women approaching the turn of the century—and their churches, homes, towns, and businesses are included in this book. In addition to the Georgia-based photographs Du Bois assembled, the exhibit of American

Negroes displayed some 150 photographs of African American educational institutions from all over the South, such as Fisk, Howard, Hampton, and Tuskegee; and houses, businesses, and churches from other parts of the country, including Richmond, Virginia; Knoxville, Tennessee; and Washington, D.C. Some of these photographs are included as well.

The first essay in the book, by Du Bois biographer David Levering Lewis, considers the historical context in which the American Negro Exhibit came to be—a statement of pride and potential at a time when racial violence and Jim Crow laws were rising in the United States. The second essay, by photo historian Deborah Willis, discusses black photography at the turn of the twentieth century and the role these photographs played in shaping a new identity for African Americans. In the course of working on her essay, Willis identified one of the photographers who took several of the photographs in Du Bois's Georgia exhibit, as well as the identity of several of the subjects—the first time anyone has been named since the photos were displayed in 1900. In doing so, she has made a significant contribution to scholarship and enhanced our understanding of Du Bois's intentions and the way he went about curating his images.

The American Negro Exhibit was considered a great success in the black press, and the white U.S. Commissioner-General to the Paris Exposition praised it highly. At the time, descriptions of the exhibit stressed that Du Bois's contribution was the charts of Georgia's progress—he personally received a gold medal for his work. Yet in all of his published works, he wrote only one sentence about the photographs in the Exposition: "There are several volumes of photographs of typical Negro faces, which hardly square with conventional American ideas." The people in Du Bois's Georgia photographs—the variety of their skin tones and facial structures a direct contradiction of stereotyped ideas about African Americans' physiognomy—went unnamed in 1900 and the landscapes and townscapes unidentified. Nor were the

5. 6.

photographers noted. Perhaps, to Du Bois the sociologist, these images were merely speci-
mens or representatives, serving the same purpose as the numbers on a chart: evidence in
his meticulously documented case for progress and the diversity that existed in this "small
nation of people" less than one generation out of slavery.

 While Du Bois's charts and graphs have been superseded, a footnote to history, these
photographs reach out across time to declare their beauty and humanity. They give a face
to the past, when individuals rose above prejudice and ignorance to live full and hopeful
lives. And they add meaning to the story of the courage and struggle of millions of African
Americans to overcome segregation and racism and to celebrate their unique selves, their
families, and their communities.

<div align="right">

LINDA BARRETT OSBORNE
Editor, Library of Congress

</div>

A Small Nation *of* People

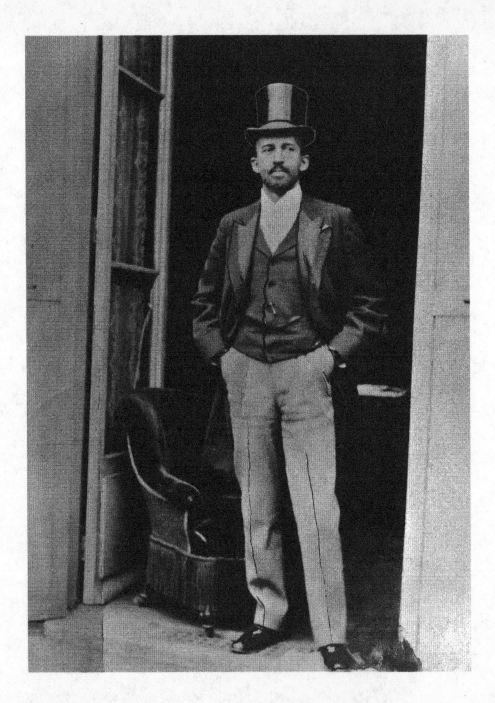

A Small Nation of People: W. E. B. Du Bois and Black Americans at the Turn of the Twentieth Century

BY DAVID LEVERING LEWIS

THE AFRICAN AMERICAN NEWSPAPER the *Colored American* brought good news in July 1900: "Dr. W. E. B. Du Bois sailed this week for Europe." The stylish young professor—who in Paris would pose in morning coat and top hat—was sailing from New York with several trunks filled with materials for the Exhibit of American Negroes at the Paris Exposition, a world's fair celebrating the close of the nineteenth century. He left his wife, Nina, five months pregnant, in Atlanta, where Du Bois taught at the university. He recalled being "threatened with nervous prostration" after finishing his part of the Negro Exhibit and having "little money left to buy passage to Paris, nor was there a cabin left for sale." Knowing well that the exhibit would fail without him, he took steerage.[1]

Du Bois had been enlisted to participate in the Exhibit of American Negroes at the Paris Exposition by his friend Thomas Junius Calloway. When they were undergraduates together at Fisk University, Du Bois described Calloway as carrying himself with the distinction of a United States senator. Tom Calloway was a man of studious purpose and racial pride whose virtues proved singularly helpful in the years ahead to the undertakings of Du Bois, his even more studious and racially focused classmate. Together they had run the *Fisk*

7. W. E. B. Du Bois in Paris, 1900.

Herald, the oldest of the Negro college magazines, with Du Bois as managing editor in 1887 and Calloway as business manager. When Du Bois, fresh from graduate study at the University of Berlin, applied to several institutions for a teaching position in the summer of 1894, he listed good friend Calloway, now principal of Mississippi's Alcorn College, as one of his references. Appointed one of the state commissioners for the Atlanta and Cotton States Exposition of 1895, Calloway became a valued lieutenant of Booker T. Washington, principal of Tuskegee Institute, whose oration at the Atlanta Exposition that year excited the nation. Washington called for whites in the South to allow blacks gradual economic progress in agriculture and business, in exchange for the latter's virtual surrender of the right to vote and social equality. His speech became known as the Atlanta Compromise.

At the turn of the century, Washington was the most influential man of color in America. In his congratulatory telegram to the Tuskegee educator on his speech, Du Bois doubtless spoke as much for himself as for Calloway in stating that Washington's accommodationist message to the white South was "a word fitly spoken." Two years later, Calloway accepted the position of assistant principal of Tuskegee. Publication of Du Bois's *The Souls of Black Folk,* the book that would crystallize fierce antagonisms between the followers of Washington and Du Bois, was a half dozen years in the future.[2]

The brief interval between the Atlanta Exposition of 1895 and the Paris Exposition Universelle of 1900 was one of relative harmony and collaboration within the emergent Negro leadership class, in both the North and the South. The initial unease experienced by a tiny, mainly Northern minority upon reading Dr. Washington's race-relations prescriptions would simmer slowly at first as the century turned, erupting as full-blown, widespread skepticism only in the decade after the appearance of *The Souls of Black Folk.* Yet, even then, Du Bois himself would betray an astonishingly elitist indulgence of the franchise restrictions imposed by the

states of the former Confederacy upon the black and white poor alike. "The alternative thus offered the nation," he wrote in *Souls*, "was not between full and restricted Negro suffrage; else every sensible man, black and white, would easily have chosen the latter." [3] If Booker Washington and his disciples wagered their souls that the right to vote could be honorably traded for the privilege of black prosperity in the South, Du Bois and his allies defended the franchise not as a universal right but as a class privilege essential to promoting the highest civic virtue above, as well as below, the Mason-Dixon Line. That both formulas were tragically defective as solutions to the so-called race problem would lead to the paradox that the dominant Washington group and the Du Boisian minority blamed each other for the dismal state of race relations that was caused primarily by white America.

In the winter of 1899, however, when Thomas Calloway sent an appeal to leaders of the race to lend their support for a Negro exhibit at the Paris Exposition, all shades of opinion united in positive response. The letter perfectly exemplified the citizenship ideals of its recipients: men and women like Archibald Grimke, Mary Terrell, and Monroe Trotter, who thought of themselves first as Americans, who merely happened to be dark-skinned. They were people who preferred to conceive of identity in terms of nation rather than race. "The signs of the times are hopeful in every way for all our citizens regardless of race," trumpeted the *Colored American*, a weekly newspaper published in Washington, D.C., on November 24, 1900. [4] Indeed, many, if not most, would come reluctantly to embrace the dichotomy of racial identity famously postulated by Du Bois when he wrote of an everlasting "two-ness—an American, a Negro; two souls, two thoughts, two unreconciled strivings; two warring ideals in one dark body." [5]

Not until the time when all hope of political rights and social equality had been definitively foreclosed in the second decade of the twentieth century (the "nadir," as the era

would be called) did Calloway and other leading black Americans think of themselves as Negroes first. Deploring "as deeply as any other member of my race the matter of drawing the color line at any time where it is not already drawn by the other race," Calloway in his letter to influential blacks eloquently justified the exceptional reasons for a Negro pavilion at the Paris Exposition:

> Everyone who knows about public opinion will tell you that the Europeans think of us a mass of rapists, ready to attack every white woman exposed, and a drug in civilized society.... The social and political economists of The Old World put down the erroneous accounts of such [infamous rape cases] as that of Sam Hose as truth, and, not hearing the actual facts, reach conclusions which do us wrong.... How shall we answer these slanders?[6]

There could be no more effective response to such libels, Calloway proposed, than the presence of the best in Negro life at the Exposition Universelle. Calloway recalled the general public's commendable responses at Atlanta and Nashville, sites of the recent, hugely successful fairs where exemplary materials drawn from the lives of people of color had been displayed. The better to show themselves as representative Americans, it was strategically imperative that Negroes be seen as a proud, productive, and cultured race at Paris.

Calloway's Paris gambit was taken in hand by Representative George Henry White, Republican of North Carolina and the sole surviving Negro member of Congress. Where once more than a score of Southern men of color had served in the U.S. House of Representatives and two in the Senate, the definitive triumph of white supremacy by the end of the century not only terminated their presence on Capitol Hill but the right of ballot to all but a few

thousand black people living below the Mason-Dixon Line. White was the last of the breed that had emerged from Reconstruction, the nation's rather abruptly dismantled experiment in universal manhood suffrage. Bowing to the inevitable, he exited Congress in 1901, not to be succeeded until 1928, but George White's parting words befitted both the pathos and the promise of the occasion. "This, Mr. Chairman, is perhaps the Negroes' temporary farewell to the American Congress; but let me say, Phoenix-like he will rise up some day and come again."

Eventually, the House voted the sum of fifteen thousand dollars (ten thousand less than White requested) to fund the Negro exhibit at the Paris Exposition, and authorized appointment of a special commissioner, salaried annually at thirty-six hundred dollars, to "collect, prepare for exhibition, and superintend" this enterprise. On January 25, 1900, an extremely pleased Calloway informed Booker Washington of the Senate's positive action. "I suppose [it] will be signed by the President within 24 hours. Public sentiment was so unanimous in its favor that the only questions asked me have been 'Is it enough?'"[7] It was understood, of course, that Calloway was to serve as special commissioner under the authority of Thomas Peck, the commissioner-general assigned to arrange and direct the affairs of the United States pavilion and its annexes.

Planning for the Negro exhibition proceeded apace. Calloway's talents as lobbyist and organizer were immediately complimented by the bibliographic resources of Daniel Alexander Murray, Assistant Librarian of Congress since 1881, the networking of Andrew F. Hilyer of the National Negro Business League, and the imaginative scholarship of Du Bois at Atlanta University. Hilyer, a graduate of the University of Minnesota and now prominent man of affairs in the nation's capital, assembled a statistical record of black business in the South. Of twenty thousand African Americans in business, blacksmiths numbered ten thousand and barbershop owners five thousand; boardinghouse keepers and "hucksters" some

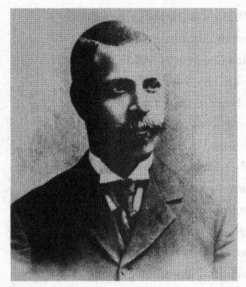

8. Daniel A. P. Murray, circa 1900.

two thousand each; manufacturers, builders, and under-
takers Hilyer counted in the hundreds. "And more than
700 of these businesses had been established more than
thirty years," the *Colored American* reporter would exude
from Paris.[8]

Murray worked tirelessly on the compilation of
the first comprehensive bibliography of works written by
people of color in the United States. The high-toned *Col-
ored American* took note of the undertaking on the eve of
the opening, boasting of 270 titles that included, among
other lost, rare, and ignored treasures, poetry by Phillis
Wheatley and Paul Laurence Dunbar; autobiography by
Frederick Douglass, Elizabeth Keckley, and Daniel A.
Payne; history by William Wells Brown, George Washing-
ton Williams, and Du Bois's monumental *The Suppression
of the African Slave Trade to the United States*. Murray's bibliography would ultimately
number some fourteen hundred works, more than two hundred of them lining the shelves
at Paris.

In the meantime, Du Bois had sprung into action in Atlanta, working frenziedly
from early February to late May. Developing his idea to focus on the state of Georgia, the
state with the largest nonwhite population, he used the twenty-five hundred dollars remit-
ted by Calloway to purchase and label hundreds of photographs and to assemble a coterie
of salaried helpers and students to prepare detailed charts for Paris. With a "couple of [his]
best students," Du Bois set about putting "a series of facts into charts." Far more than "the

usual paraphernalia for catching the eye," he designed his exhibit to subvert conventional perceptions of the American Negro by presenting to the patronizing curiosity of white spectators a racial universe that was the mirror image of their own uncomprehending, oppressive white world. There were "photographs, models, industrial work, and pictures," but the display offered much more, he explained. "Beneath all this is a carefully thought-out plan."[9] That carefully thought-out plan consisted of four parts: history of the Negro from arrival to modern times; contemporary social and economic conditions; educational progress; production of literature.

Du Bois readily conceded that lynching, peonage, poverty, votelessness, and much else hardly presented a "rose-colored picture" in Georgia, as he would assert repeatedly in the interest of objective scholarship. He copied by hand the "black codes" or laws affecting the lives of Georgia's Negro citizens from Reconstruction to the present. Nevertheless, the significant advances of Georgia's 860,000 men, women, and children of color was incontrovertibly presented through text, chart, and illustration. Public school enrollment had risen from a mere 10,000 in 1870 to 180,00 by 1897. They owned a million acres of land and paid taxes on $12 million of property—"not large, but telling figures," Du Bois emphasized.[10] The comparisons of Georgia's erstwhile slaves to certain Europeans were instructive and often surprising, as with the illiteracy rate of the former recorded as "less than that of Russia, and only equal to that of Hungary." Equally surprising, no doubt, was the fact that the Negro population of the United States was half that of the Spaniards of Spain. The detail of the charts and execution of several maps possessed exceptional instructional power, as with the large, color-coded maps prepared under his direction showing the distribution of Georgia's Negro population across the United States and the migration of the general Negro population since the Civil War.

It is obvious that Du Bois, like Calloway and Murray, gave little or no thought to creating a more "balanced" exhibition at the Paris Exposition. The leitmotif of their show is resolutely upbeat, racially triumphalist, and progressive in the best tradition of American progressivism. No lynching images jar the spectator. Scenes drawn from the everyday life of the black poor are in the style of sanitized exoticism later made familiar by *National Geographic*. Although the Negro Exhibit displayed photographs of the homes of the "poorer classes" in Chattanooga, Tennessee, typical of reality in the United States, in number and arrangement such photographs are atypical of the reality exhibited at Paris. Photographs of factory work serve to depict the march of industry in an idealized New South with scant hint of the racialized dead-end confronted by tens of thousands of black peasants seeking a living in the towns and cities. The workers ("lumpers") at the T. B. Williams Tobacco Company in Richmond, Virginia, sit in serried rows, self-consciously attentive as though attending a lecture, their burly white supervisors standing by in feigned respectfulness. Had this photograph captured these men engaged in their sweltering, muscle-rending labor an hour earlier, facial expressions and body language would almost certainly have conveyed a more problematic message.

Conversely, the images of representative Negroes—of the educated, the prosperous, the phenotypically advantaged—are cynosures of all the characteristics and virtues of which most whites, either in ignorance or from bigotry, believed most blacks to be devoid. Dark-skinned citizens whose features betoken undiluted African ancestry gaze in high-collared or bonneted distinction from offices, pews, and parlors. The range of Du Bois's photographs also betrays a decided preference for African Americans of lighter hue. Indeed, many of them portray people of such idealized European appearances that, as intended, they must have confounded the aesthetics, affronted the self-esteem, and trumped the civilizationist assumptions

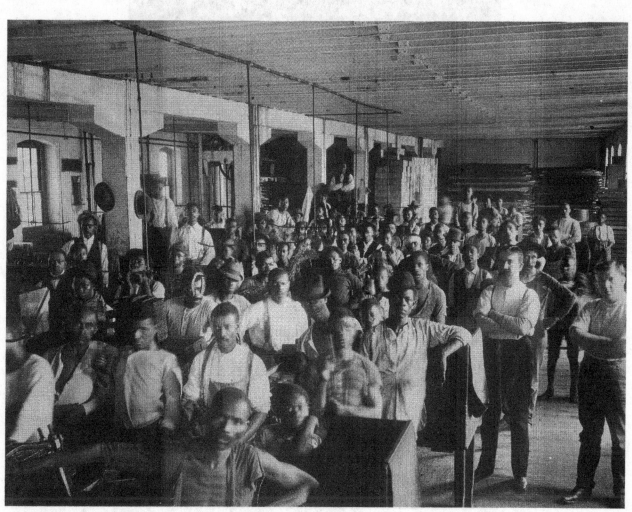

9. "Lumpers" at the T. B. Williams Tobacco Company, Richmond, Virginia.

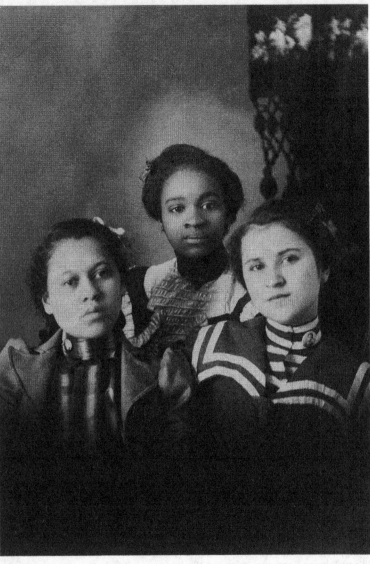

10.

of the white people who came to see the Negro section. Half-length representations of matinee-idol males with aquiline features and femmes fatales with coils of raven hair rebutted the denigrations of Thomas Jefferson's *Notes on Virginia*.

Very likely, Du Bois had no need to spend a large portion of his budget for the acquisition of photographs, postage fees aside. Almost certainly, he must have made specific requests of certain individuals such as Thomas Askew, an Atlanta photographer; possibly he hired the occasional photographer. But for others besides Du Bois, the Negro Exhibit at Paris was a racial imperative, a momentous opportunity and obligation to set the great white world straight about black people. The leadership class of black America rallied to the effort. Educational institutions forwarded their best pictures— the "five great Negro schools," Atlanta University, Fisk, Hampton, Howard, and Tuskegee, joined by others—a

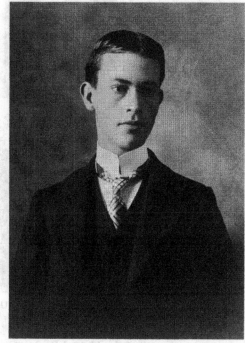

11.

library scene at Claflin University in Orangeburg, South Carolina; students at morning prayer at Fisk University; dentistry classes at Howard University; vocational instruction at Tuskegee Institute; and science classes at the Agricultural & Mechanical College of Greensboro, North Carolina.

Businesses and individuals from around the country also contributed. The Southern Hotel, a smallish, white structure, appeared neat and elegant, an oasis in the segregated

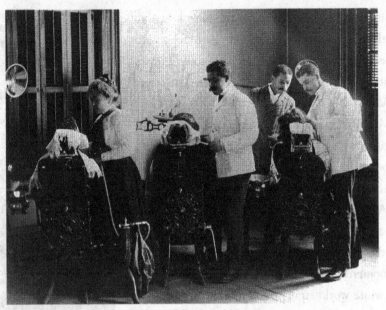

12. Dentistry at Howard University, Washington, D.C.

capital of the United States. Confident young black men, aproned and efficient, stand by equipment in the composing room of the Richmond *Planet*, one of the major black-owned weeklies. Stern members of the Board of Directors of the Coleman Manufacturing Company in Concord, North Carolina ("the only Negro cotton mill in the United States"), exude an almost palpable pride as they face the camera. Among the pictures of imposing homes contributed by affluent black Americans, those of millionaire Memphis businessman Robert R. Church and the renowned Methodist Bishop Henry M. Turner are two of the grandest. Ministers sent photographs of churches framed in their best angles.

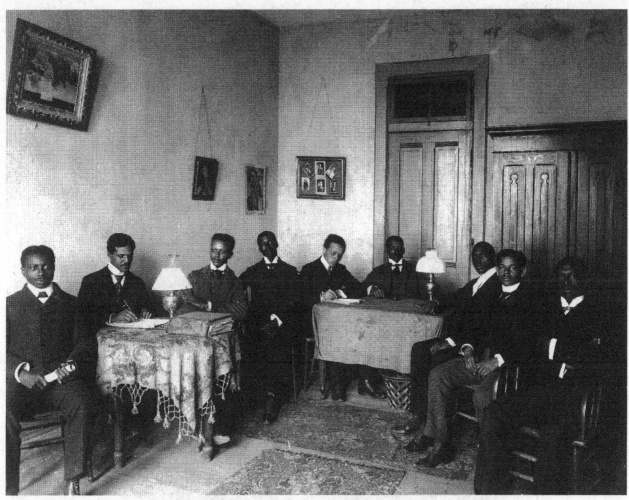

13. Extempo Club of Fisk University, Nashville, Tennessee.

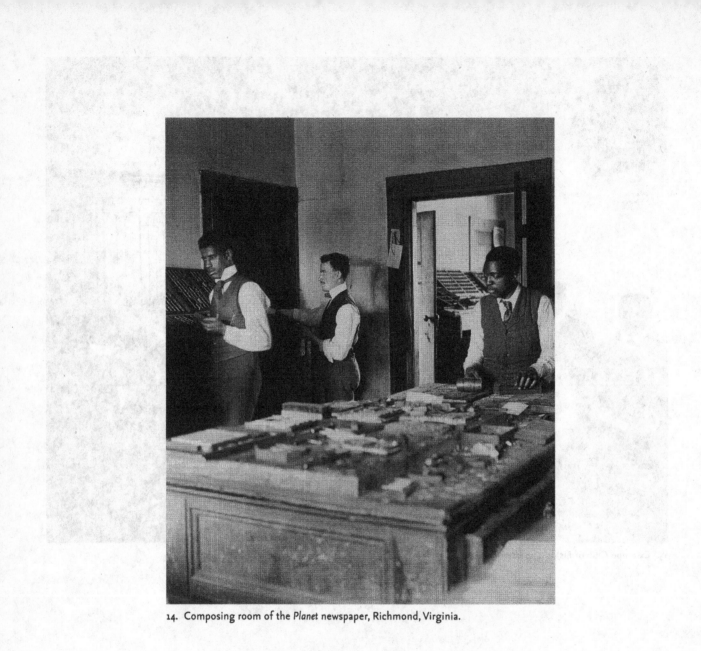

14. Composing room of the *Planet* newspaper, Richmond, Virginia.

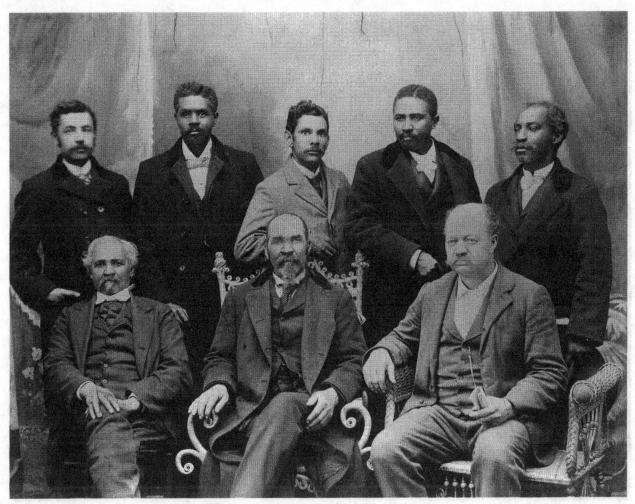

15. Board of Directors of the Coleman Manufacturing Company, Concord, North Carolina.

16. Home of Bishop Turner, Atlanta, Georgia.

Du Bois spoke for Calloway, Murray, and thousands of like-minded African Americans belonging to what he famously called the "talented tenth" when he described the exhibit as the "honest, straight-forward exhibit of a small nation of people, picturing their life and development without apology or gloss."[11] But there *was* gloss and also a great deal of wishful thinking. In many ways, the Negro Exhibit at the Paris Exposition represented the last hurrah of men and women of culture and accomplishment who still aspired to full citizenship rights regardless of color. As the twentieth century dawned, white supremacy all but nullified the deferential vision of interracial cooperation and fair-dealing Booker Washington had credulously proposed at the Atlanta Exposition only five years earlier. In several Southern states (especially in South Carolina, Louisiana, North Carolina, and Texas), although black voters were still either courted or corralled in contests for local political power, within a decade Negrophobe politicians would have all but eliminated the franchise. Mississippi's 1890 constitutional convention had pointed the way, after which barely a trace of a once-robust black Southern franchise remained. By 1900, with the work of the constitutional conventions substantially completed, Louisiana had less than 6,000 registered black voters, where before there had been more than 130,000; Alabama listed 3,000 after 1900, drastically reduced from a previous registered total of some 181,000. Without the legalistic abracadabra of the Supreme Court of the United States, however, white supremacists would have been harder pressed to complete the new order below the Mason-Dixon Line. Leaving a record of stunning judicial opacity in its civil rights deliberations, the high court moved from the *Slaughterhouse* cases of 1873 to *Plessy v. Ferguson* in 1896, invalidating the 1875 Civil Rights Act along with the First Enforcement Act and systematically stripping away the citizenship guarantees under the new Fifteenth Amendment.

However well intentioned, and even inescapable, Washington's much-debated Atlanta Compromise—abandonment of the franchise and social equality in return for some economic power—would shortly be deplored by Du Bois and increasing numbers of black people in the face of grandfather clauses, literacy tests, the ghastly 1898 Wilmington, North Carolina, riot (in which even the most respectable black citizens were massacred), and the unbroken rhythm of Southern lynchings. The fatal flaw in Washington's Faustian bargain was that the Conservatives who controlled the legislatures in the 1895 South were even then losing power or being forced to share more of it with the rising Radicals. Mississippi governor James Vardaman spoke plainly for the Radicals: "I am just as opposed to Booker Washington as a voter, with all his Anglo-Saxon reenforcements, as I am to the coconut-headed, chocolate-colored, typical little coon, Andy Dotson, who blacks my shoes every evening."

As these men and their followers captured the statehouses, the margin of maneuverability for African Americans dwindled down almost to nothing, not only in the political sphere but in practically every other arena. Boarding a train in Atlanta on a February night in 1900 to gather exhibit materials in Savannah, Du Bois was refused an overnight berth on the Cincinnati-Jacksonville express. Segregated carriage and dining facilities were already enforced aboard intrastate carriers, but rules governing accommodations aboard trains crossing state lines remained fluid and unpredictable. After being compelled to "sit up all night" in the crowded, filthy, "colored" car hooked just behind the engine, he filed formal protest with the Southern Railway Company, sending a copy of the letter to Booker Washington.[12] "What interpretation does the railway put on the phrase of law 'separate compartments'?" Du Bois demanded to know. His humiliating experience was a foretaste of the answers to come.

There was much irony in the parallel objectives of Euro-Americans and Afro-Americans at the Paris Exposition. If white Americans demeaned the humanity of colored

Americans, Europeans patronized the cultural maturity of Euro-Americans. Paris was the forum in which colored Americans hoped to win the appreciation and respect that the larger American nation denied to what Du Bois called a "small nation of people." Paris afforded a second chance for the larger American nation to demonstrate the prodigious technological and commercial achievements of a civilization that Europe persisted in discounting. Recalling the underfunded and poorly organized American pavilion at the 1889 Paris Exposition, *Century Magazine* revealed that "mortification at this Paris fiasco, and a desire to show the world what we could do," were the driving forces culminating in the magnificent 1893 Chicago World's Fair.[13] How the United States would acquit itself at the Paris Expo, therefore, was a " 'live question,' " said the prestigious monthly. Americans had a duty "no longer to suffer the elite of these Paris world's fairs to form their opinion of us from the mirror which we ourselves have held up on four or five successive occasions." The *Colored American* urged a similar special effort to accomplish much the same elevation in collective esteem. The ironic tragedy of the American racial situation, however, was that too many whites insisted on believing that they could rise only if blacks declined, that the former's civic and cultural respectability depended on the latter's invisibility in or extrusion from the public sphere.

AT THE PARIS EXPOSITION

While the *Colored American* and other black American media covered the Negro Exhibit, mainstream American newspapers generally ignored its existence during the entire seven-month run, from opening day, April 14, to the close on November 12, 1900. The possibility cannot, of course, be excluded that at least one French or foreign-language newspaper

mentioned this remarkable display. But the telling fact that both the U.S. commissioner-general and the assistant commissioner-general to the Paris Expo neglected any mention of the Negro Exhibit in their comprehensive articles in the January and April issues of the *North American Review* gave scant incentive to the foreign press to notice Calloway's handiwork.

To be fair, it must be emphasized that, unlike many fairs before and after the 1900 Paris extravaganza, most of the twenty-seven national pavilions were conceived as architectural conceits, grand spaces quintessentially redolent of their national cultures and displaying some spectacular gastronomic, technical, or artistic centerpiece. (The vastly popular Russian pavilion contained, for example, a gigantic marble and jasper map of France with cities marked by precious stones.) Large-scale exhibits and those best appreciated by careful study (like the Negro Exhibit) were housed apart in designated buildings at the Trocadéro, along the Esplanade des Invalides, or in the distant Parc de Vincennes. Assistant Commissioner-General B. D. Woodward's effusive *North American Review* article gives a good sense of layout of the buildings, most of them connected by a remarkable "electric railroad and a double moving sidewalk": "We pass in review the Palace of Education and Liberal Arts, the Palace of Civil Engineering and Transportation, the Palace of Chemical Industries, the Palace of Textiles, and the Palace of Mining and Metallurgy."[14]

Clearly, with so much to see at the Paris Expo, there was much that would be missed. Noticing the impressive pavilions at the Trocadéro devoted to the colonial achievements of Europe in Africa and Asia, an extraterrestrial visitor might still have been puzzled why American officialdom, the newest member of the club of empire, insisted on overlooking an installation funded by U.S. taxpayers that reflected much credit upon white tutelage. Writing before the official opening of the United States Pavilion on May 12, Assistant

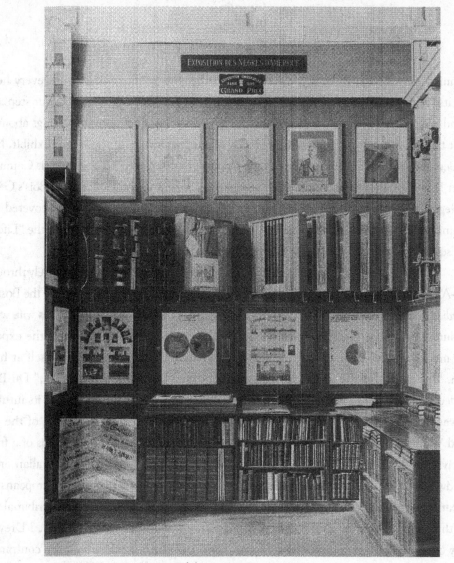

17. Interior, American Negro Exhibit, Paris Exposition, 1900.

Commissioner-General B. D. Woodward boasted that this pavilion would turn every head with its "moving stairway," a newfangled convenience on which "you select your step and ascend with it." Expatiating on the technological innovations and cultural offerings abounding at the fair, Woodward found nothing to say about the novelty of the Negro Exhibit. Nor did Georgia's leading newspaper, the Atlanta *Journal*, in its article, "Georgia's Paris Commissioner Leaves for the Big Exposition," find room then or later to comment on Du Bois's Georgia Negro Exhibit. The New York *Herald* (soon the *International Herald Tribune*) covered the opening of Madagascar's pavilion as well as the Arctic Section's presentation of the "Life of the Esquimaux," but not the Negro Exhibit.[15]

Negro Americans learned of their special contribution in Paris almost entirely through Afro-American news weeklies such as the Minneapolis *Appeal*, the Washington *Bee*, the Boston *Guardian*, Cleveland *Gazette*, and New York's *Negro World*. Du Bois's letters to his wife written during two months abroad have not survived; however, when he wrote of the experience much later, his prose caught the spirit of a civilization serenely sunning itself at high noon. "It was one of the finest, perhaps the very finest, of world expositions," Du Bois decided, "and it typified what the European world wanted to think of itself and its future." He was thirty-two, still very much a Europhile, but a good deal more critical of the so-called White Man's Burden now that he believed he detected unmistakable signs of a fraying civilization: the Ethiopian Emperor Menilek II's annihilation of a crack Italian army at Adwa in 1896 (the first significant military defeat in modern history of Europeans by Africans) he took to be a portent of epochal significance; and a French military tribunal sitting throughout the month of August 1899 at Rennes had found Captain Alfred Dreyfus guilty of treason a second time, although the identity of the real traitor and the conspiracy of the Army General Staff against the Jewish officer had been fully exposed. Wallowing in

anti-clerical and anti-Semitic orgies, the French were said by many Americans to be a disgrace to the white races.

THE NEGRO EXHIBIT

Although it was frequently called the Negro Pavilion, the Negro Exhibit actually occupied one fourth of the total exhibition space allocated to the United States in the multinational Palace of Social Economy and Congresses. An article in the *Colored American* invited readers into the Negro Exhibit where, "with arms in the attitude of speaking, is the statuette of Frederick Douglass." The newspaper printed a huge photograph of a seated Calloway flanked by Murray's library volumes, and above him likenesses of Booker Washington, Reconstruction U.S. Senator Blanche K. Bruce, and Minister to Liberia Ernest W. Lyons. Also above the special agent, rows of hinged boards are to be seen. In a rare departure from the general American mainstream indifference, an article on the Social Economy pavilion praised the exhibit's clever adaptation of the wing-frame arrangement. "Mr. Calloway had a series of frames on which were displayed metal-work, clothing, carpentry, harness, and agricultural products"—all viewable in a compact space, enthused the author.[16]

A few paces beyond, Du Bois's cornucopia of Southern life in charts, illustrations, objects, and photographs fills the aisles, and the *Outlook*'s surprised commentator urged that serious attention be paid, "for the mass of information represents too much labor to have its value impaired." Professor W. H. Tolman, secretary of the League for Social Service and author of the article, judged the "before" and "after" photographs of the Hampton and Tuskegee experience to offer dramatic evidence of the "economic freedom of this race."[17]

A few weeks earlier, the steadfast *Colored American* had pulled out the editorial stops upon discovering another favorable notice of the Negro Exhibit in the *Academy*, the literary world's "leading book authority." "That the Afro-American is rising cannot be doubted by the most Negro hating pessimist," the magazine assured its genteel readers, now that Daniel Murray's book exhibit had been praised in the arbitral British publication.[18]

When the Exposition awarded its prizes, the effort of American Negroes was recognized. Although not everything had been uncrated when the judges passed, what they saw impressed them enough to award Du Bois, "Collaborator as Compiler of Georgia Negro Exhibit," a gold medal. Special agent Calloway was equally lauded, receiving a gold medal for the exhibition's general conception and success. Once the installation of the African American display was completed, Calloway's and Du Bois's labors could be fully appreciated as the tour de force of enterprise, imagination, and modest resources they objectively were. The Negro Exhibit won a Grand Prix for the entire collection, a Grand Prix for Hampton University, a total of fifteen gold, silver, and bronze medals, and an honorable mention for Claflin University.

The *Colored American* understandably cited these accolades as incontrovertible proof of the quality and impact of the Negro presence at the Paris world's fair. "Few things have been done for us in the last two decades that have counted so much for our dignity and capacity," the magazine crowed, "as the winning of so many prizes." Although there was truth to the claim, a characteristically objective Du Bois would insist on putting things in proper perspective. His late arrival—due to time and budget constraints—had deprived the prizes of what he called "the even balancing that might be wished." Because the juries had disbanded before most of the major features had been installed (with the notable exceptions of Atlanta, Fisk, Hampton, Tuskegee, and Howard), Du Bois regretted that the medals didn't "represent the strongest features of the exhibit."[19] This was an intellectual's

cold water poured into the tub of boiling Negro press assessments at the close of the great fair. For better and worse it was largely ignored.

On the night of August 7, most, if not all, of the Afro-American visitors to Paris attended a formal dinner at the U.S. pavilion. It was a glittering affair, lubricated by champagne and momentarily liberating from the marginalizing realities of Jim Crow America. Separate but splendidly equal under the roof of their nation's ultimate showplace in Europe, the crème de la crème of colored America enjoyed a well-deserved evening of bibulous self-validation. Du Bois and Calloway were present. Adam Clayton Powell Sr., the charismatic Baptist preacher; Meta Vaux Warrick, a promising art student; Anna Julia Cooper, the future voice of black feminism; Norris Herndon, one of the richest men in the South; Andrew Hilyer, the well-connected Washington businessman; and several score more attended. "There were many good speeches in response to the postprandial toasts," glowed the *Colored American*. Ironically, under the heading "American Negroes Dine," the New York *Herald* allowed its first and only notice of compatriots of color who met "for the first time under the hospitable roof of the United States building in a foreign land."[20]

The great international carnival of the fin de siècle closed in early November 1900. The *Colored American* opined that the world was a better place thanks to the instructive work of Calloway and Du Bois at Paris: "The peoples of other countries will know the Negro American better and think more of him hereafter than they have done before."[21] To that end, it would have enlightened the great majority of Du Bois and Calloway's compatriots had the New York *Herald* deemed it worthwhile to carry news of the Negro Exhibit's award of a grand prize and fifteen medals. The influential newspaper mentioned only that the United States had swept the field in agricultural awards and that the McCormick Harvesting Machine Company won well-merited honors.[22]

The official report of the commissioner-general for the United States was published some three months after the close of the Paris Exposition. Commissioner Ferdinand Peck's report could hardly have omitted the existence of an activity approved by both houses of Congress and funded by the American taxpayer. Even so, Peck's discussion of the Negro Exhibit was strikingly complimentary. He praised it as having been "the most unique exhibit in the American section, if not in the whole exposition of social economy," and singled out Calloway and Du Bois as "scholarly and intelligent representatives of the race work of which they were exhibiting."[23] Calloway was invited to submit an itemized report of the exhibit's contents, which was appended to the commissioner's document. Such consideration was well merited. Beyond the gratification it must have brought Du Bois and Calloway, however, the principal readers of the commissioner-general's report were a handful of federal bureaucrats and a few historians in the future.

The last world's fair of the nineteenth century ran its course without any awareness on the part of the American public at large that there had ever been a "most unique exhibit in the American section." What Du Bois and Calloway had wanted to demonstrate to the world about the progress and promise of people of color in America had become almost an epistemic impossibility for the majority of their white countrywomen and -men by the dawn of the twentieth century. For, just as a significant percentage of Du Bois's small nation of people stood ready to walk onto the world stage as aspiring, able, even assimilated, participants in the social contract, a peculiarly American version of white supremacy twinned with Herrenvolk democracy, consigned all black people to the shadowy margins of the national life where their invisibility would long remain indispensable to the identity of white people.

But three years after the close of the great fair, *The Souls of Black Folk* appeared, striking a far more somber note about the future of race relations than those heard on that festive August night in the U.S. pavilion. "The problem of the twentieth century is the problem of the color-line"—Du Bois predicted—"the relations of the darker to the lighter races of men in Asia and Africa, in America and the islands of the sea."[24]

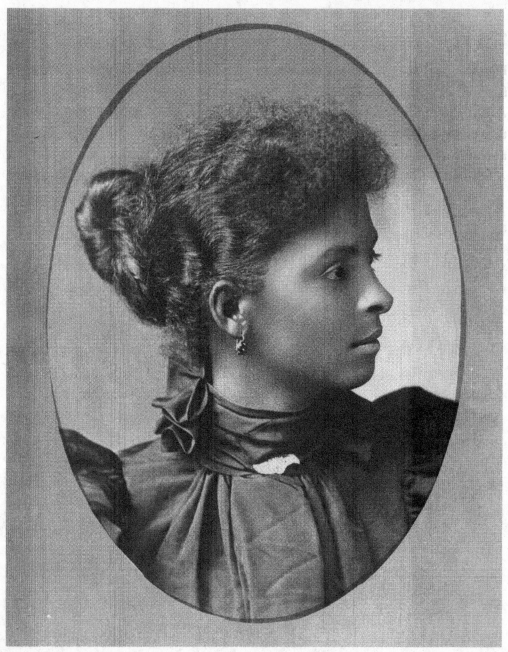

18.

The Sociologist's Eye:
W. E. B. Du Bois and the Paris Exposition

by Deborah Willis

Twenty-three years after the Paris Exposition, W. E. B. Du Bois shared his personal fascination with the medium of photography in his "Opinion" column in *Crisis*, the magazine of the National Association for the Advancement of Colored People: "Why do not more young colored men and women take up photography as a career? The average white photographer does not know how to deal with colored skins and having neither sense of the delicate beauty or tone nor will to learn, he makes a horrible botch of portraying them."[1]

Du Bois's use of photographs at the Paris Exposition, remarkable, in his words, for the variety of their "delicate beauty [and] tone," shows his understanding of the power of photography to create a new and revised self-image for African Americans. Photography played a critical role in reconstructing and shaping American visual culture at the turn of the twentieth century. Black photographers, whose work Du Bois drew on for the Paris Exposition, offered a provocative challenge to the blatantly stereotypical images of African Americans as inferior, unattractive, and unintelligent. Their photographs served as evidence that black Americans were as multifaceted as anyone else, and they played an important role in making the black experience visible.

Historian Douglas Daniels writes that during the late nineteenth and early twentieth centuries, "Whites' images of Blacks in newspapers, reminiscences, and history books often

contrast with Blacks' image of themselves. Sometimes favorable, frequently paternalistic, Whites' descriptions focused on colorful idiosyncrasies."[2] But there is a stylish, cosmopolitan quality to the photographs made by their black contemporaries. According to Daniels:

> Culture conscious Blacks, sensitive to their appearance as evidence of quality, joined societies and clubs to acquire social skills and poise. They believed that images of refined Negroes could counter the stereotypes, so positive images were invariably featured in Black-written newspaper articles.... Flattering images of the urbanites were also projected in photographs.... These images present to us the Afro-Americans as they wished to be seen and remembered.[3]

Black photographers created a new visual language for "reading" black subjects, an image of self-empowerment—a "New Negro," an expression first used when a reporter for the *Inter Ocean* asked the question, "Is He a New Negro?" after hearing Booker T. Washington's speech at the 1895 Atlanta Exposition.[4] Washington's speech marked the beginning of a new era, a new visualization of African Americans. In the following years, the term "New Negro" came to represent a spirit of self-awareness, artistic consciousness, and racial pride that arose in black communities after 1900 and was reflected in different media, including art, print, artifacts, photography, and film. The New Negro movement believed that all men and women were created equal and was prepared to offer a broader visualization to prove it.

A photograph in the Booker T. Washington Papers at the Library of Congress offers an excellent example of the changing perception of African Americans. The photo depicts an older and a younger black man at the side of a road with horse-drawn buggies in the background. The younger man is wearing a suit and tie, and the old one is without a tie—

his wrinkled pants indicate that he is a laborer. Someone, perhaps Washington himself, inscribed on the photo, "Old and New at Utica Miss Oct 6 00." They are visual representations of the Old Negro and the New Negro.

Through the photographers' lenses, we can see the embodiment of racial pride and the beginnings of the notion of a New Negro visual aesthetic. Black photographers created transformative photographs of New Negroes— beautiful, educated, employed, and exploring their dreams. Some gained national recognition as businessmen and artists, and many promoted a resistance to negative imagery by consciously advertising their craft in black periodicals and organization newsletters.

Although the last half of the nineteenth century was a time of pervasive racial discrimination in the United States, black communities created their own news and community organizations, schools, churches, and businesses, including photographic studios. It was a time when

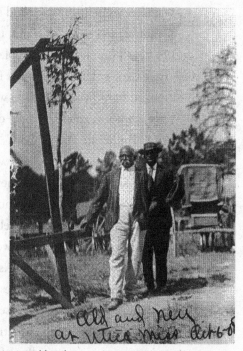

19. "Old and New at Utica Miss," October 6, 1900.

most images made by white Americans showed blacks as subordinate to the dominant race, but photographers began to record images of black people seeking an education, new lives, new identities, new prospects, and new jobs (often in urban centers)—alternative and positive images of the black experience.

Photography played a critical role in giving voice to the emerging black middle and upper social classes. Inside African American communities, photographers recorded black

families attending church and sporting events and engaging in other spiritual, recreational, political, and social activities, though, in some areas, it wasn't easy to have a picture taken. In South Carolina, for example, some white photographers posted signs indicating the days that their studios were open for blacks, and some refused to serve them at all. Signage ranged from "Visits from the whites will be received on Monday, Tuesday, and Wednesday of each week, colored people on Thursday, Friday, and Saturday," to "No Coons Allowed" and "For White People Only."[5] But that did not discourage members of the black community. The photographic image was considered as powerful as the written word as black people struggled to persuade the American public to change their notions about race and equality.

African American photographers participated in the dissemination of photographs of black subjects at every level. Some were exhibited; some were published in newspapers, journals, and books. Others were purchased directly from the photographic studios by the subjects and their families. As most of these transformed images were owned by middle-class and working-class families, removed from the public sphere, very little has been written about the image of the black self in photography during this period.

Reading and interpreting photographs of black subjects taken in the late nineteenth century requires a rereading of the literature about the New Negro and the cultural history of photography. Cultural historian Alan Trachtenberg argues that the rise of photography to a position of social text is significant in reading images today. He writes:

> American photographs are not simple depictions but constructions...that the history they show is inseparable from the history they enact: a history of photographers employing their medium to make sense of their society. It is also a history of photographers seeking to define themselves, to create a role

for photography as an American art.... Consisting of images rather than words, photography places its own constraints on interpretation, requiring that photographers invent new forms of presentation of collaboration between images and text, between artist and audience.[6]

I would argue that black photographers and their subjects believed that defining their own identity and beauty through photography was a significant step in the fight against negative representations. Photography played a role in shaping people's ideas about identity and sense of self; it informed African American social consciousness and motivated black people by offering an "other" view of the black subject. In a sense, photography was used as what I call "subversive resistance."

The photographs at the Paris Exposition portrayed an African American community that was spiritually, socially, and economically diverse. This was a radical notion at the time, and when you consider the long, violent history of African Americans, this sense of self and self-worth takes on a deeper meaning. Looking at these representations of the New Negro provides us with a new paradigm in which to explore the visual interpretation of the New Negro as a self-conscious/race-conscious image, and the significance of the photographic image in the study of racial uplift.

DU BOIS AND THE GEORGIA EXHIBIT

Du Bois had only five months to develop the plan for his exhibit before the opening of the Paris Exposition in April 1900. He was pleased to be involved, as he later wrote:

In 1900 came a significant occurrence which not until lately have I set in its proper place in my life. I had been for over nine years studying the American Negro problem. The result had been significant because of its unusual nature and not for its positive accomplishment. I wanted to set down its aim and methods in some outstanding way which would bring my work to the notice of the thinking world. The great World's Fair at Paris was being planned and I thought I might put my finds into plans, charts, and figures, so one might see what we were trying to accomplish. I got a couple of my best students and put a series of facts into charts: the size and growth of the Negro American group; its division by age and sex; its distribution, education, and occupations; its books and periodicals. We made a most interesting set of drawings, limned on pasteboard cards about a yard square and mounted on a number of moveable standards.[7]

It is interesting to note that upon arriving in Paris, Du Bois went to Nadar Studios, one of the city's best photography studios, to have his portrait taken. It appears that Du Bois knew the terrain of photographic studios. His portrait shows a young scholar sporting a Vandyke beard and high-collar shirt. It was used to create his exposition identity card, which is actually a carte-de-visite attributed to the photographer Paul Nadar (1856–1939), son of the much-celebrated portraitist Felix Tournachon Nadar (1820–1910). Nadar's studio was known for its work with celebrities, the rich and famous of Parisian society.[8]

As a sociologist, Du Bois's main interest in the Georgia exhibit was in the conditions of black Americans since the end of slavery. As curator, he presented, with charts and graphs, the results of his own research on the black family and his analysis of the progress of blacks after Emancipation. But he also offered a critical view of black visual culture by presenting

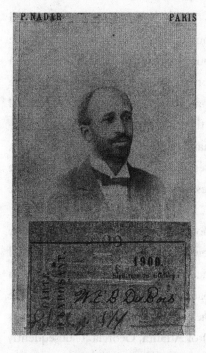

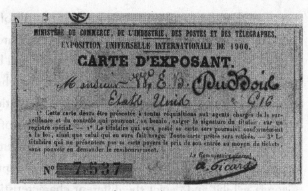

20. W. E. B. Du Bois, identity card, Paris Exposition, 1900.
21. *Above:* Reverse side.

photographs of the new life of blacks in Georgia. He chose 363 photographs, including many of well-dressed, self-conscious young men and women: unidentified students and leading members of the Atlanta community as well as portraits of their sons and daughters. By presenting unidentified portraits that showed the diverse skin colors of black Americans, he used the power of photography to imagine a reality rarely acknowledged at international expositions at that time. In fact, African Americans voiced their disapproval of the African villages and other racial stereotyping at the 1893 Columbian Exposition in Chicago. Ida B. Wells-Barnett, journalist and anti-lynching crusader, and Frederick Douglass published a pamphlet, "The Reason Why the Colored American Is Not in the World's Columbian Exposition," to inform the rest of the world of the travails of black Americans in both the North and the South.

Du Bois intended to show not the travails of African Americans, but, in accord with the Paris Exposition's theme, their progress. Through photographs, he presented the "typical" educated black child, businesswoman, and businessman, the symbolic images a testament to this progress. Du Bois as curator, the photographers as interpreters, and the subjects as models all collaborated in this visualization. Each had a political and visual agenda that relied on a photographic representation of the New Negro. The scholar, minister, entrepreneur, mother, father, brother, sister, nursemaid, student, musician, homeowner, surrey driver, and even the femme fatale are all represented in the photographs in the Georgia exhibit and depict the different characteristics of these lived experiences of the New Negro.

Although most of the photographers are unknown, on my first trip to the Library of Congress to do research for this essay, I noticed a few of the portraits looked familiar. I remembered that one of these images had been reproduced in my previous book, *Reflections in Black: A History of Black Photographers*. When I compared the two, they were, indeed, the same. Unidentified for the exposition but later titled *The Summit Avenue Ensemble*, this was a group portrait taken by Thomas Askew (1850?–1914) of Atlanta, Georgia. I subsequently contacted Atlanta-based archivist and collector Herman "Skip" Mason of Digging It Up, Inc., and visited the archives at Atlanta University, the Atlanta History Center, and the Auburn Avenue Research Center to find more information on the photographs. I looked at both Skip Mason's books and the photographs in the archives to identify more of the portraits. One was of the photographer Thomas Askew himself.

We therefore now know that Du Bois commissioned at least one local Atlanta photographer, Thomas E. Askew, to provide photographs of the private homes, churches, and businesses owned by blacks in the state. "Atlanta had a relatively well developed black middle

class...which was reinforced by Atlanta University and a black press," according to scholar Donald Grant.[9] The New Negro's desire to achieve middle-class status is found in these photographs, a desire that ran in direct opposition to the human displays found in world's fairs and expositions hitherto. Cultural historian Shawn Michelle Smith writes:

> Unlike the exoticized displays of African villages that reinforced white European estimations of their own "civilized" superiority in relation to "Negro savages," the American Negro exhibit of the Paris Exposition represented African Americans as thoroughly modern members of the Western world.... The exhibit was considered one of the most impressive in the Palace of Social Economy and was honored with an exposition grand prize.[10]

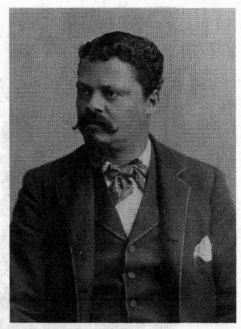

22. Thomas Askew, self-portrait.

Askew, whose photography studio was located in his home on Summit Avenue, was married to a seamstress, Mary Askew. Clothing was a key signifier for the New Negro, and it is likely that Mrs. Askew's profession inspired her husband to focus his attention not only on the faces of his subjects but also their dress. Askew's own self-portrait shows him in a self-conscious pose, with full mustache and beard and side-parted hair. He is wearing a narrow-lapel wool suit, vest, and a bow tie, and his portrait serves to validate his middle-class status in the community.

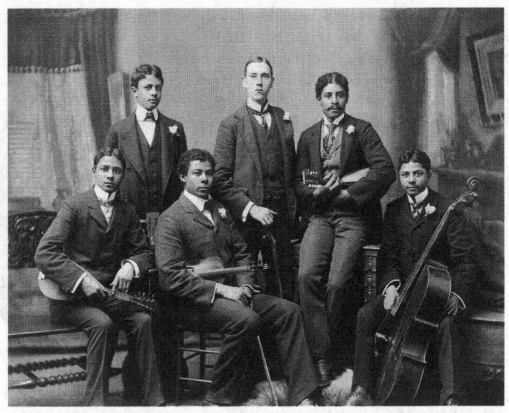

23. The Summit Avenue Ensemble, Atlanta, Georgia. *From left:* Clarence, Norman, and Arthur Askew; Jake Sansome; Robert and Walter Askew.

Askew and his wife had nine children—three daughters and six sons; most of them posed for their father and their images were selected and displayed in the exposition. *The Summit Avenue Ensemble*, for example, shows the photographer's sons and neighbor with their musical instruments. Conservatively dressed with boutonnieres, they look directly at the camera. Askew's twin sons, Clarence (seated) and Norman, are at the left; Arthur and Walter are also seated; and neighbor Jake Sansome and Robert stand behind them. The photograph offers a glimpse into the home studio of the photographer on Summit Avenue and middle-class black life, including the signature lace curtains used by Askew in most of his portraits.

Askew's photographs of his sons and daughters reveal much of his interest in the arts. Portraits of his daughters wearing sailor dresses and ruffled-collar dresses, holding and reading large art books, and posed near studio props such as replicas of Roman soldiers, show Askew's eclectic taste. Other portraits of young girls and women wearing lace scarves, portrait brooches, drop earrings, lockets, ostrich plume hats, bracelets with charms, and feather boas were significant indicators for each subject. They recast the New Negro as a collector of fine clothing,

24. Daughter of Thomas Askew, Atlanta, Georgia.

25.

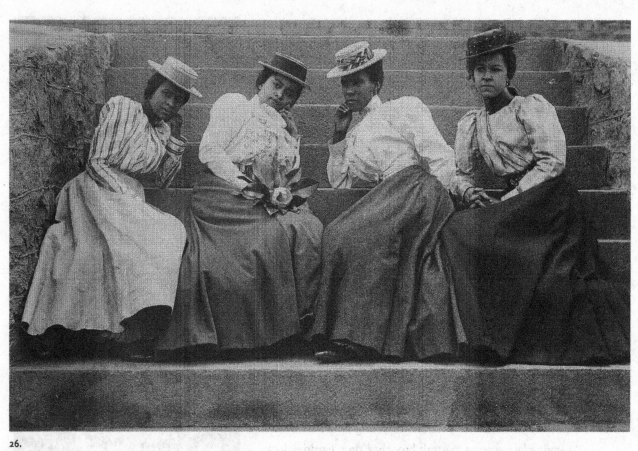

26.

preserver of ancestral mementoes, and enthusiastic participant in the image of the "New Woman."

Fashion historian Joan Severa has pointed out that at the end of the nineteenth century, "the New Woman took action and made certain that her dress allowed her to participate more fully in all aspects of life. This trend ensured that women had more physical freedom and that the new styles of clothing were accessible to the millions."[11] The New Negro Woman was not excluded from this description. The photograph of four female students posed on the steps of a building on the campus of Atlanta University show this active participation in life. They are dressed in everyday walking dresses with leg-o'-mutton sleeves. Their stylish straw hats, a trend of the late 1890s,[12] are tilted, and each woman

is in a relaxed pose. The one on the far right wears drop earrings, another is holding a flower. Another photograph of nine young female students outside a different building shows these fashionably dressed women posing for the photographer. The mix of clothing ranges from casual to Sunday best.

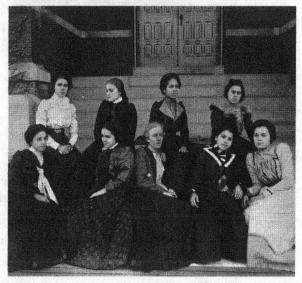

Du Bois's interest in creating a narrative about the dreams of young students can be seen in other portraits that are attributed to Askew. One quietly celebrates the professional aspirations of a young woman, a nursing student wearing a starched white uniform and cap and a heart-shaped charm bracelet, 27.

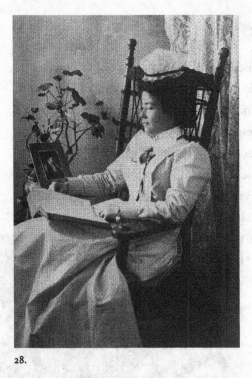

28.

posed with an open book in a rocking chair. Within the shot, a framed photograph of a woman, possibly the nurse's relative, sits on the table next to the chair and near a large plant. Another portrait of the same woman shows her wearing a fur collar and a lace dress with a rose pinned to it; on her exposed neck is a necklace with a cross. The pose offers the viewer an alternative display of the subject's feminized body. These photographs function alternately as woman as professional and woman as desired object.

For the Georgia exhibit, Du Bois chose not only photographs of children and women dressed stylishly, but regal studies of black men, such as the Reverend Henry Hugh Proctor (1868–1933), also taken by Askew (see page 66). The photograph of Dr. Proctor wearing suit and tie identified this leader as a prominent figure in his community. He was educated at Fisk and Yale, and was a well-known and respected minister of the First Congregational Church of Atlanta. Through this portrait, Proctor symbolizes the leading black man of the late-nineteenth-century South. In presenting photographs that seem both typological and emblematic, Du Bois exhibited a curatorial vision that can be seen as both aesthetic and political.

29.

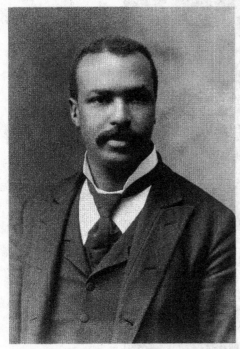

30. The Reverend Henry Hugh Proctor, pastor of the First Congregational Church, Atlanta, Georgia.

When we look at the photographs Askew took of these people, we can see a tension in the well-dressed students and residents of Georgia. The style of dress worn by the subjects reveals the status of the sitters, either real or hoped for; we see them today as class-conscious blacks. I suggest, as Joanne Entwistle notes in her book *The Fashioned Body*, that "this tension between clothes as revealing and clothes as concealing of identity" is an important aspect of the photographs commissioned and collected by Du Bois.[13] Historian Hazel Carby asserts that Du Bois believed "clothes can be read, unproblematically, as clear signs of intellectual work."[14]

Askew's photographs captured a wide range of experiences that emphasized the newfound class attitudes of his subjects. Like most black photographers working in studios in the late 1890s, he recognized the aspiring middle class and the newly prominent race leader as worthy subjects to record. Most of the photographs in the exhibit are still unattributed, but the images identified as his reflect his ability to devise ways to use composition, props, and studio setups to establish a space where people could express themselves visually, intellectually, spiritually, psychologically, emotionally, and symbolically.

Countless photographers maintained props (drapery, classical columns, and parlor furniture) in their studios—symbols of social status, wealth, and intellect. Often these props

were used as a source of empowerment: a lectern to suggest an orator; a pillar for respectability; books for intellect; a framed photograph for connected lineage; and drapery for a sense of class and gentility. Props and clothing allowed black photographers like Askew to counter stereotyped depictions of black people, which often have been governed by prevailing attitudes toward race and sexuality. Ultimately, they provided African Americans the opportunity for reinvention.

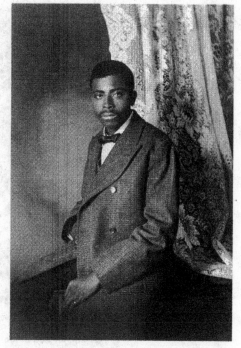

31.

The photographs Du Bois selected were powerful and engaging portraits that enabled the viewer to see how African Americans used the studio photographer to redefine themselves. He used the camera as a collector of evidence to support his sociological findings. In framing his subject as the Georgia Negro, Du Bois asked his audience to reexamine their notions of the Southern black. The photographs in the exhibit reflected the ideals of the Victorian era and those of an emerging black middle class. Photographs of interiors of well-furnished living rooms and music rooms, with art, flowers, and family photographs prominently placed, changed perceptions about the home life of black people.

By including photographs of community life, homes, and domestic environments, Du Bois offered clues to the cultural spirit of Atlanta's black middle class. For example, he presented a photograph of the First Congregational Church as an example of one of the

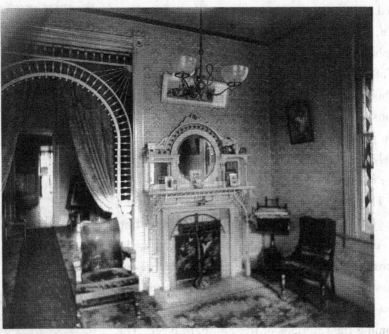

32. Interior view of room showing chandelier, decorative arch, and furniture, Georgia.

most progressive churches of the period. A brick structure with stained glass windows, the church served the community's religious, educational, and recreational needs.[15] A group portrait showing the minister, Dr. Proctor, and other members of the congregation, including the photographer, Askew, allows us to see the diversity of church members' genders and ages. A woman wearing a mourning dress appears to be a central figure in the group. Other images of men and women posing outside of their homes on upper and lower porches, on high steps, and near corner stores show the vitality of this community.

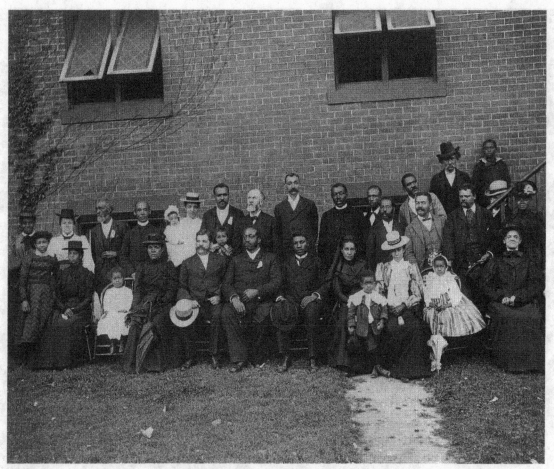

33. Members of the First Congregational Church, Atlanta, Georgia, pose outside the brick structure. Seen in the photograph are the Reverend Henry Hugh Proctor (*standing, seventh from left*) and Atlanta photographer Thomas Askew (*standing, third from right*).

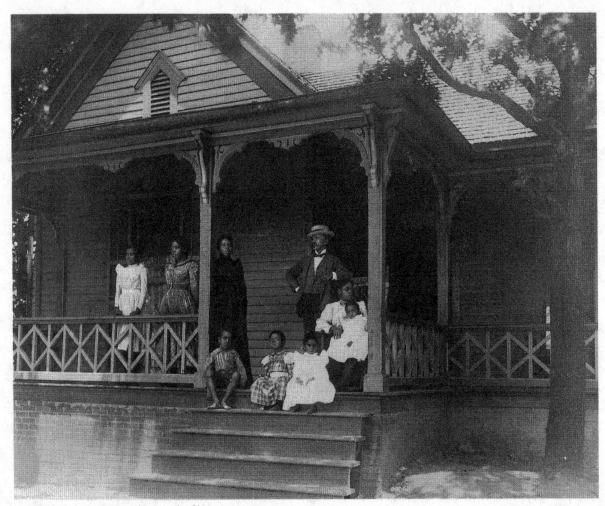

34. African Americans posed on porch of house, Georgia.

35. Country store, Georgia.

OTHER PHOTOGRAPHS
AT THE EXHIBIT OF AMERICAN NEGROES

The photographic albums of Georgia exhibited by Du Bois in Paris reflect his perceptive understanding of the importance photography would have as historical memory for future generations. Both he and Thomas Calloway valued the medium of photography and used it as a source to depict life and promote art. It was probably Calloway who solicited "six institutions...to contribute the education features and the other material" displayed in the Exhibit of American Negroes as a whole.[16] Among these contributions were photographs that Calloway notes were provided by the following people and institutions:

- Coleman Manufacturing Company, Concord, North Carolina, a cotton mill "owned and operated by Negroes"
- C. E. Fleetwood of the War Department, Washington, D.C., "photographs... of Negro soldiers and sailors" awarded medals of honor
- Hampton Normal and Agricultural Institute, Hampton, Virginia
- Howard University, Washington, D.C.
- Bishop B. F. Lee of Wilberforce, Ohio, "photographs of Negro self-development in church and school"
- Roger Williams University, Nashville, Tennessee
- Shaw University, Raleigh, North Carolina
- Tuskegee Normal and Industrial Institute, Tuskegee, Alabama[17]

Black educational institutions such as Tuskegee and the Haines Industrial Institute in Augusta, Georgia, displayed examples of their students' handiwork; Fisk sent exam papers; and Hampton included a model bank. Thus several universities and schools had their own small exhibits to show the progress made in educating African Americans.

Calloway's report on the American Negro Exhibit describes some of the visual attractions provided by schools and individuals:

> In this case were photographs of several educational institutions, viz: Fisk University, Howard University, Roger Williams University, Agricultural and Mechanical College, Greensboro, N.C.; Berea College, Tuskegee Institute, and Claflin University. These photographs showed buildings, grounds, and classes at various kinds of work, and miscellaneous views of school life.
>
> There were also photographs of many negro houses, such as those of Bishops Gaines, Holsey, and Turner; Messrs. Snell and Nash, of Atlanta, Ga.; Messrs. Murray, McKinley, and Dr. Grimke, and a street view in Eleventh street, Washington, D.C., showing a solid block of fine houses occupied by negroes.[18]

Calloway made special mention of the photographs of the Hampton Institute, taken by Frances Benjamin Johnston, a noted documentary photographer. Hampton was awarded a Grand Prix at the Exposition, as was the American Negro Exhibit as a whole. (Calloway and Du Bois received gold medals.) Calloway wrote in a letter to Johnston, "I am happy to inform you that the exhibit of the Hampton Institute is attracting considerable attention and has had many favorable comments."[19]

36. Biological laboratory, Agricultural and Mechanical College, Greensboro, North Carolina.

Calloway also hired Harry Shepherd to photograph black colleges and universities for the Paris Exposition. Shepherd, who was the first black photographer to own a studio in St. Paul, Minnesota (opened in 1887 when he was thirty-one), was a highly respected photographer. He won a gold medal at the 1891 Minnesota State Fair for his collection of cabinet cards. The St. Paul *Appeal* notified its readers on February 3, 1900:

> Mr. Harry Shepherd, our photographer, has been appointed by the Exposition Commissioners official photographer for the Art-American exhibit which is being arranged under management of T. J. Calloway, who was recently appointed

37. Home of Bishop Gaines, Atlanta, Georgia.

by the President. The appointment of Mr. Shepherd is quite an honor and a compliment to his artistic ability that he may well be proud of and the good citizens of the State as well. He receives a very handsome salary, $4 per day for expenses and is also paid for each picture taken, so there really is a small fortune in it for Mr. Shepherd. He left last week for Chicago, where he met Mr. Calloway and they went South to begin their work.[20]

Traveling with Calloway, Shepherd met with and photographed students at Atlanta University and Tuskegee. His composite photographs of schools in the South indicate his

compassion for the subjects and their work. He was, however, later dismissed after he allegedly attempted to organize black Southerners with his openly expressed anti-segregationist views. A blistering attack by a black journalist on Shepherd's activities was published in the *Afro American Advance*:

Shepherd has been in the southern states for some time securing photographs for use in his department, but he took occasion while there to preach anarchy and advised the Negroes to combine against the United States in the event of war with foreign powers. This, he says, is the only solution of the race problem. When taxed with his misconduct he made no denials and after his discharge openly boasted to a reporter of a local paper of circulating inflammatory circulars while in the South.... We regret to learn that Mr. Harry Shepherd has lost that "fat position." This race problem is a delicate question to deal with, particularly when a good position is at stake. Fortunate people are not without an army of enemies and conservatism ought always to be the watchword of the lucky.[21]

Shepherd's response to the attack was published in the rival *Appeal*:

38. "Tuskegee Institute, and Its Industries," by Shepherd Photo Company, St. Paul, Minnesota, circa 1900.

The *Advance* should not lose any sleep over the "fat position" lost by Harry Shepherd. The business of the Shepherd Photo Company amounts annually to from $12,000 to $20,000, and Shepherd has expended more money in fighting the Afro-American battles in the last few years than would be necessary to run half a dozen such papers as the *Advance*. Besides, there was a certain sum set aside for the purpose of which Shepherd was commissioner, and that was exhausted when Shepherd had been out four weeks. . . . If the Afro-American papers of this country are satisfied to fill their columns with frivolous matters, while a portion of our brothers and sisters in the South are being sentenced to prison on trivial charges and kept in perpetual bondage—that is their business. I work along my own lines. If I fail, I am alone. I ask neither advice nor sympathy. Harry Shepherd.[22]

These accounts of Shepherd's militancy and his financial situation provide considerable insight about him as a race man, artist, and businessman. And his documentary photographs, as well as those made by Thomas Askew and others, not only reflected their time but ultimately created a remarkable record of the progress of blacks, urban and rural life, and the class structure of blacks at the turn of the century. Framing the New Negro images within the context of the Paris Exposition, Du Bois's sociologist's eye, and the photographers' vision allows us to see the self-image projected by the sitter, think critically about the history behind the photograph, and explore the transformation of the mythos projected on the black community both by its own members and by the dominant culture. As we look at the photographs today, the difficulties of the past appear removed and unimaginable. These photographs explore a corrective visual history as they are read as images of self-empowerment, self-determination, and self-recovery.

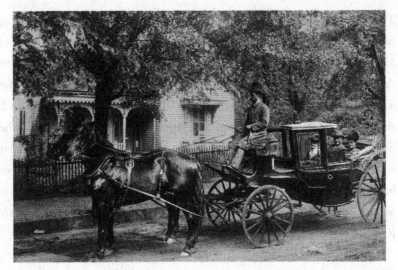

39.

What are we to make of these extraordinary images? They played a crucial role in examining and reinterpreting the dreams and ideals of both the black scholar and the working class by making socially relevant and class-conscious images of the African American community. The photographs not only counter the negative black imagery typically promoted in popular culture, they document a body of images of a vibrant family life and a growing middle class, transform the subjugated black imagery, and force all Americans to reexamine history as they learned it. These photographs do what only the finest photography can achieve: they create a new awareness and historical consciousness, exemplifying pride and determination, that has the power to rewrite history itself.

SELECTIONS FROM

THE PHOTOGRAPHS AT THE

Exposition des Nègres d'Amérique,

"Exhibit of American Negroes"

PARIS EXPOSITION, 1900

*"There are several volumes of photographs
of typical Negro faces, which hardly
square with conventional American ideas."*
—W. E. B. DU BOIS,
"The American Negro at Paris,"
NOVEMBER 1900

40.

41.

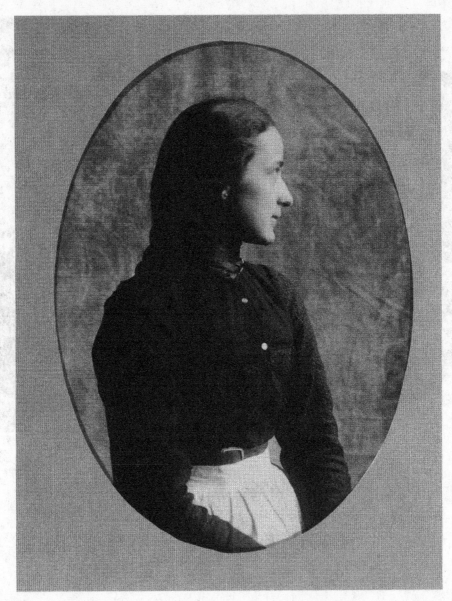

42.

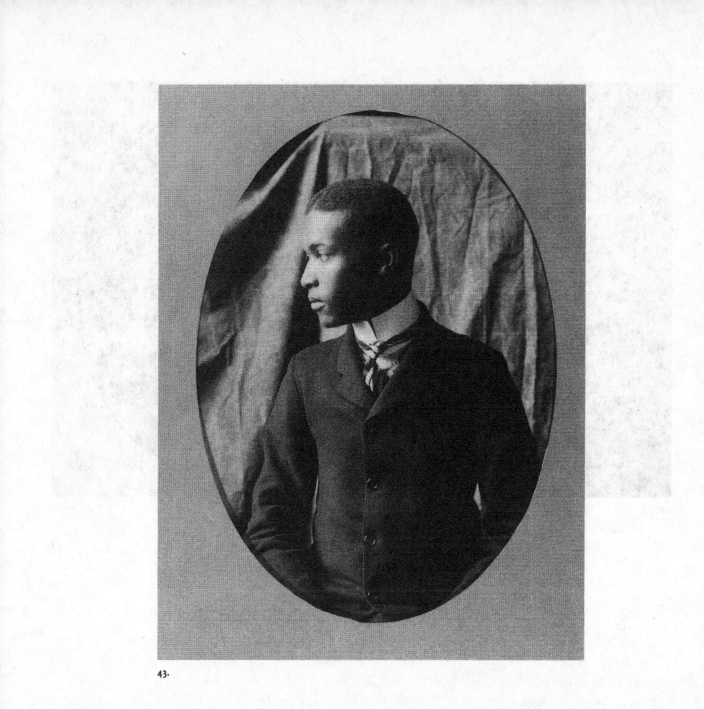

43.

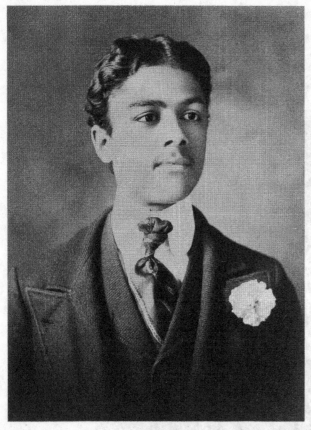

44.

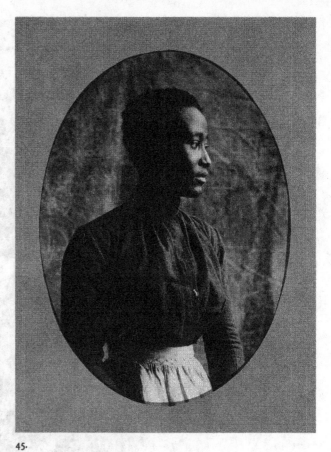

45.

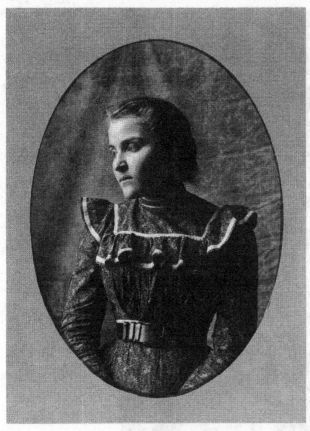

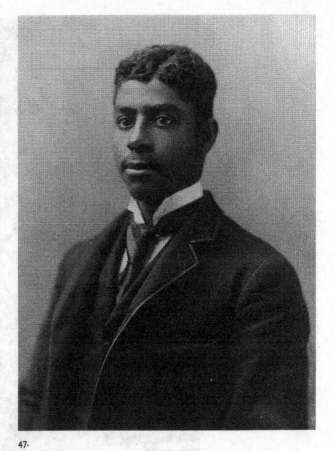

46.

47.

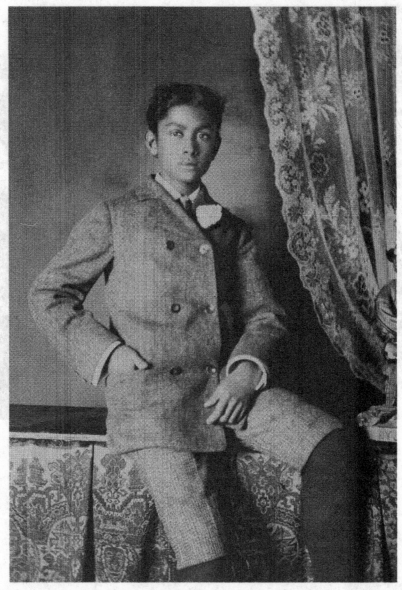

48.

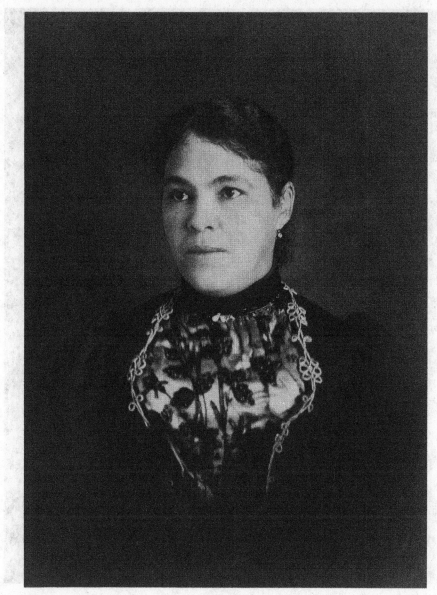

49.

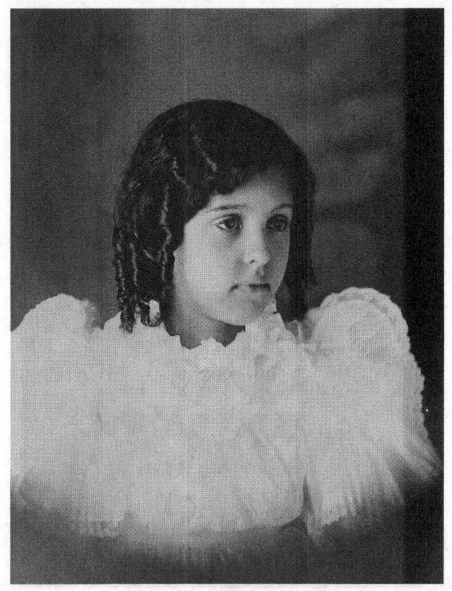

50.

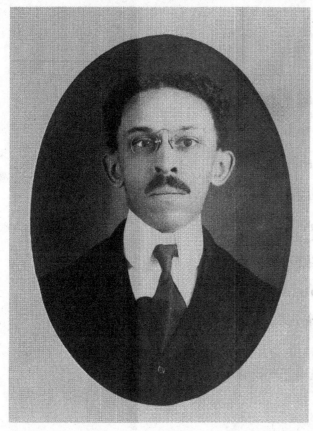

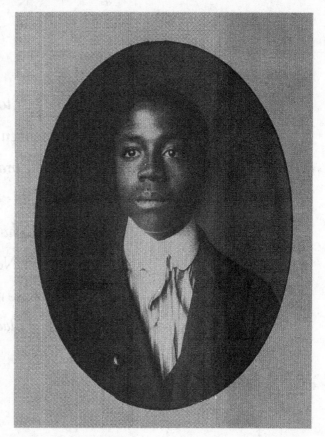

51.

52.

"Our song, our toil, our cheer...
have been given to this nation
in blood-brotherhood.
Are not these gifts worth the giving?
Would America have been America
without her Negro people?"

—W. E. B. DU BOIS,
The Souls of Black Folk, 1903

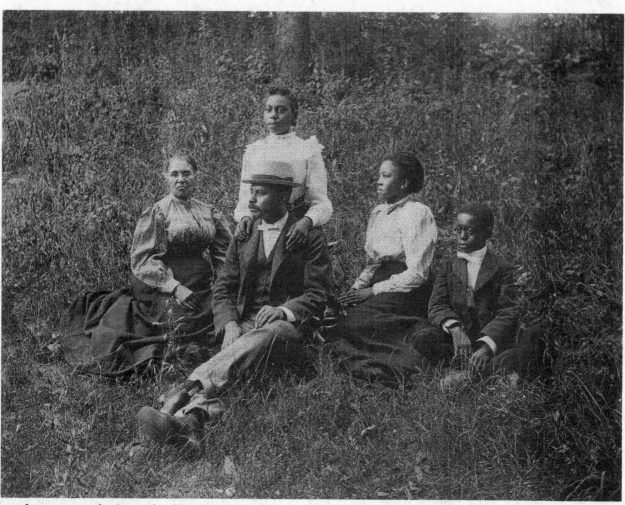

53. African American family seated on lawn, Georgia.

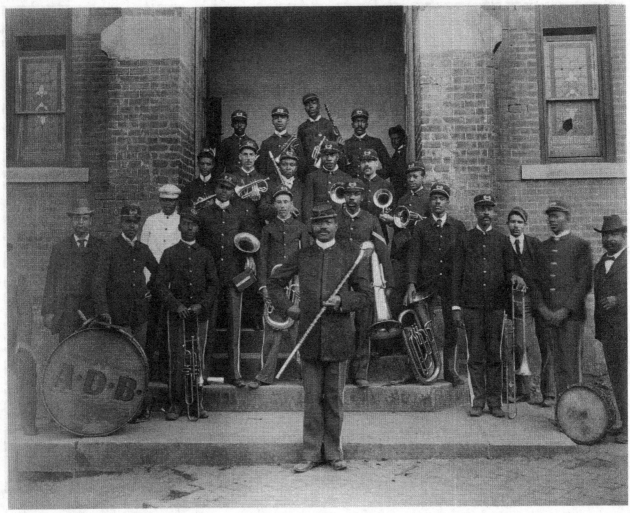

54. African American band on steps, Georgia.

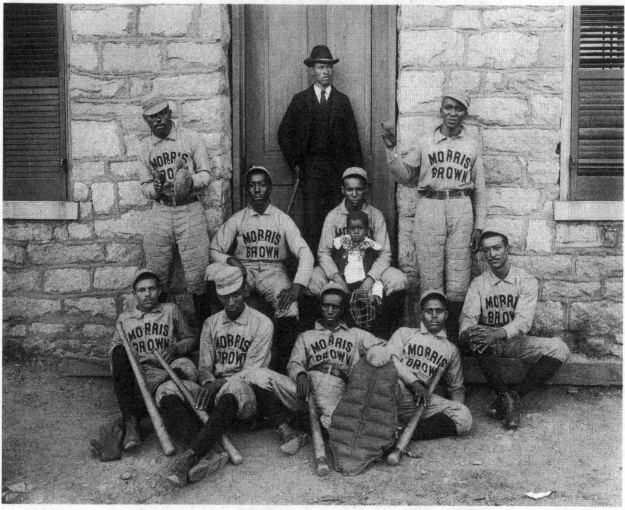

55. Baseball players, Morris Brown College, Georgia.

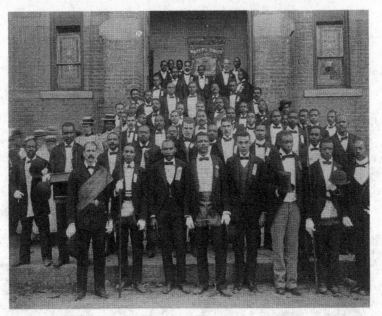

56. Waiters Union, Georgia.

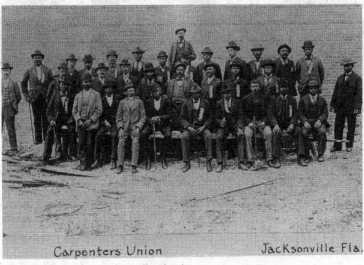

57. Carpenters Union, Jacksonville, Florida.

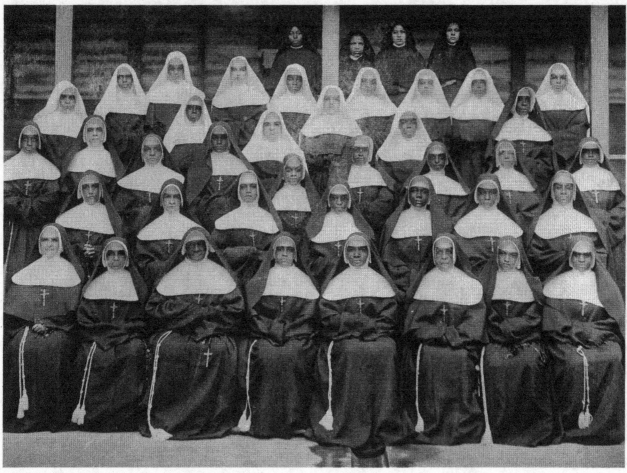

58. Sisters of the Holy Family, New Orleans, Louisiana.

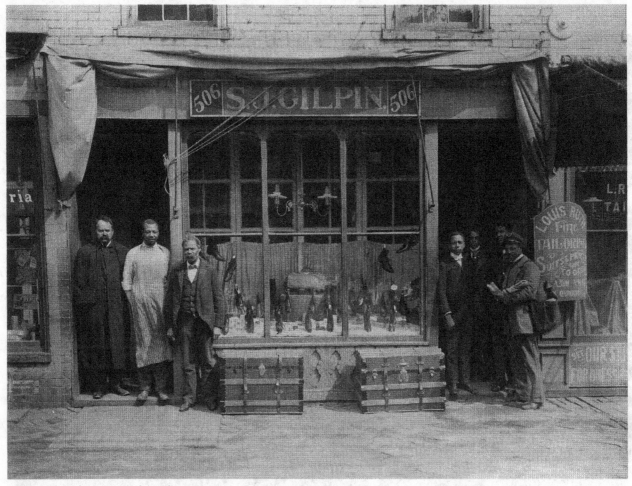

59. S. J. Gilpin shoe store, Richmond, Virginia.

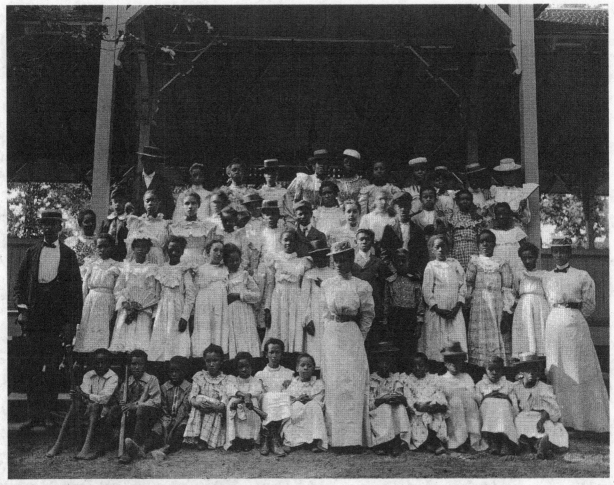

60. African American children and adults in a pavilion, Georgia.

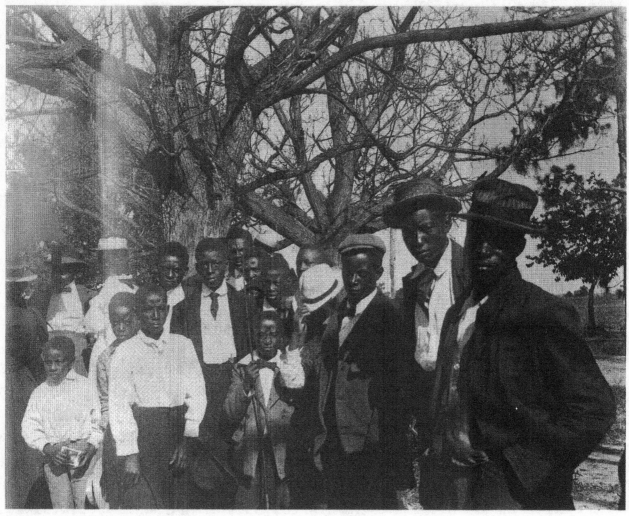

61. Men and boys dressed for church, Georgia.

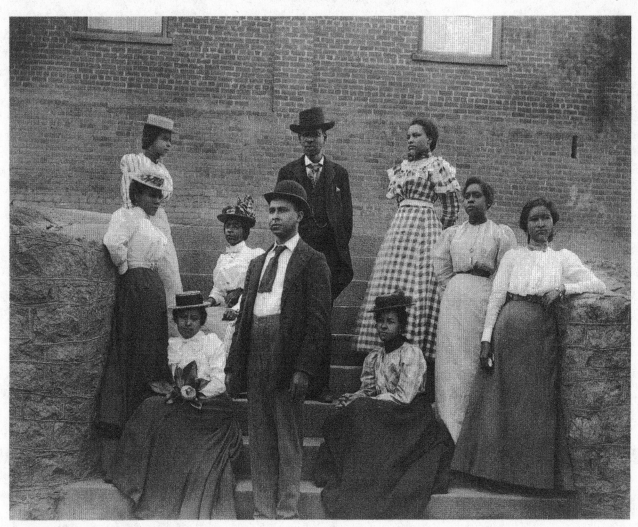

62. Men and women on steps, Georgia.

"Work, culture, liberty—all these we need,
not singly but together, not successively but together,
each growing and aiding each,
and all striving toward that vaster ideal
that swims before the Negro people,
the ideal of human brotherhood,
gained through the unifying ideal of race."

—W. E. B. DU BOIS,
The Souls of Black Folk, 1903

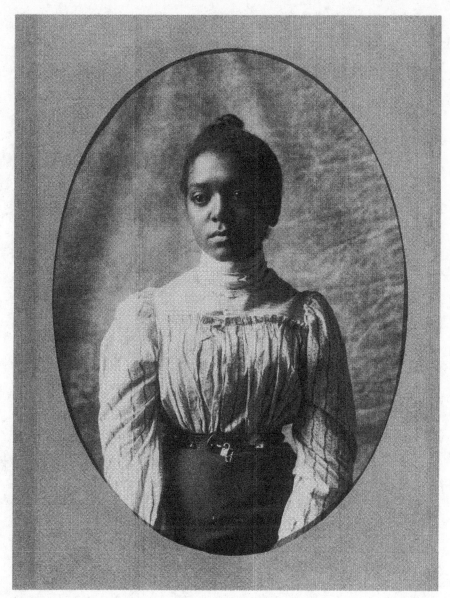

63.

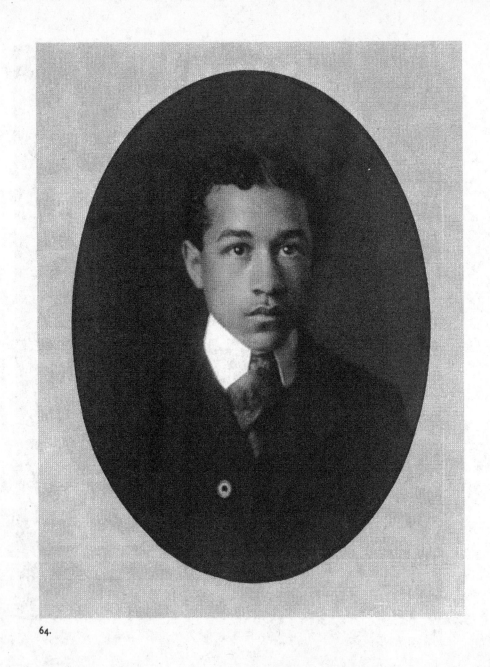

64.

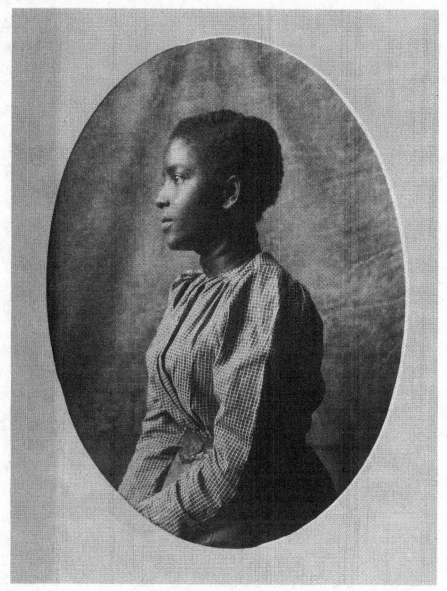

65.

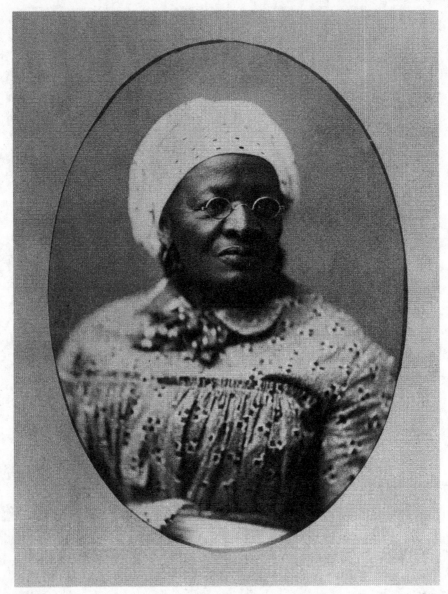

66.

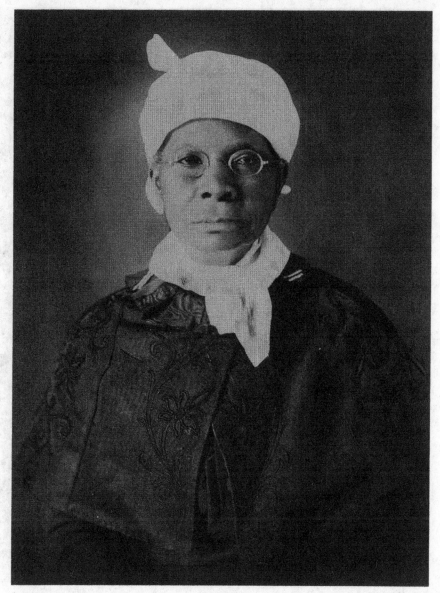

67.

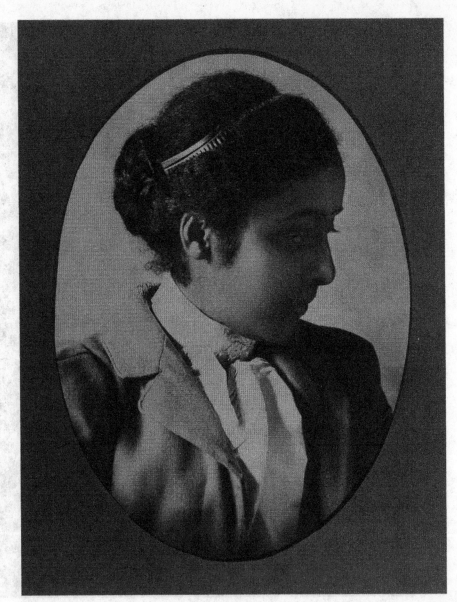

68.

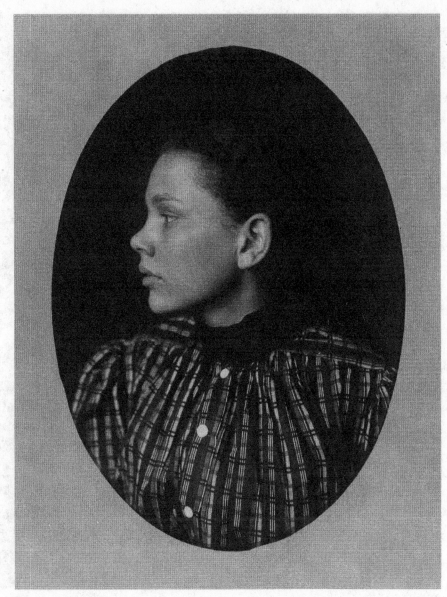

69.

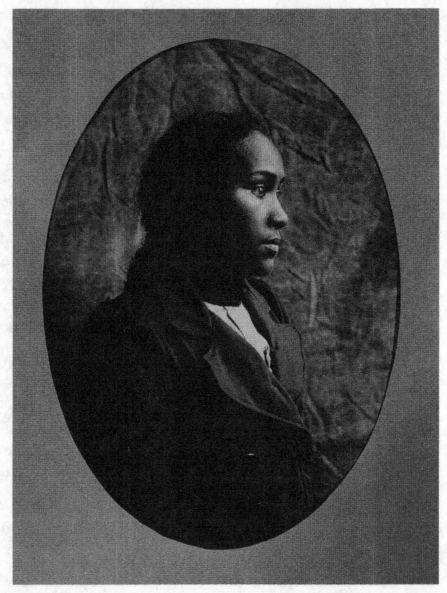

70.

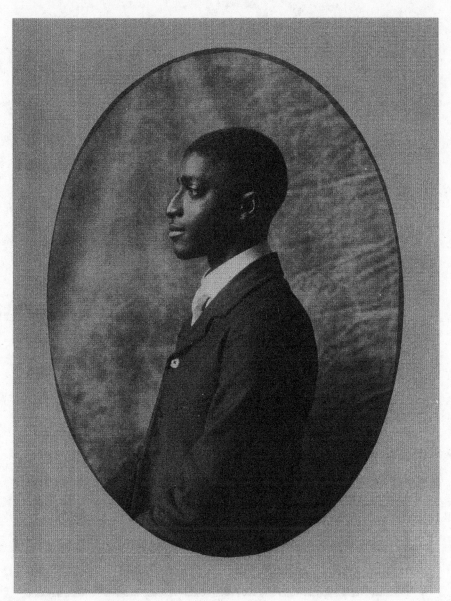

71.

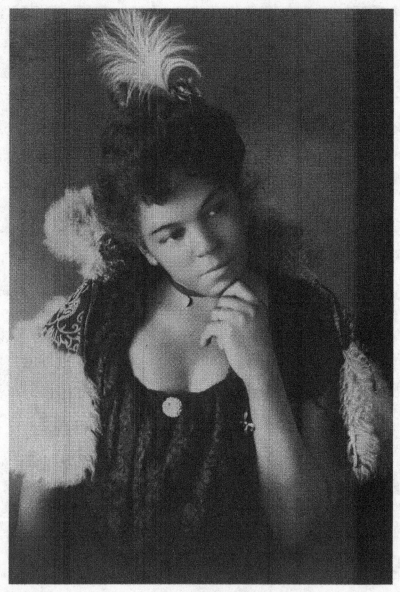

72.

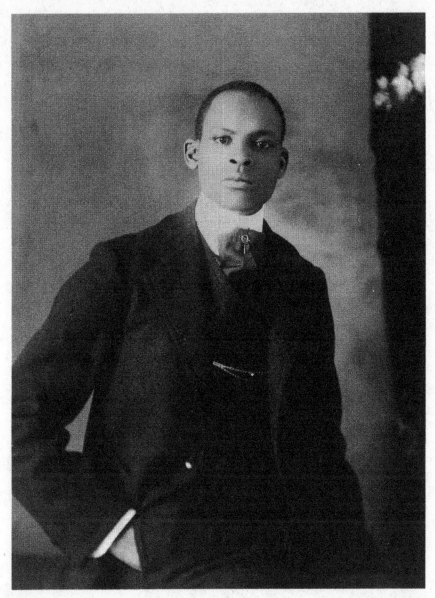

73.

"Thirty years ago the Negroes of this country
owned nothing, not even themselves;
they now own property aggregating
in the neighborhood of $940,000,000."
—Colored American,
APRIL 21, 1900

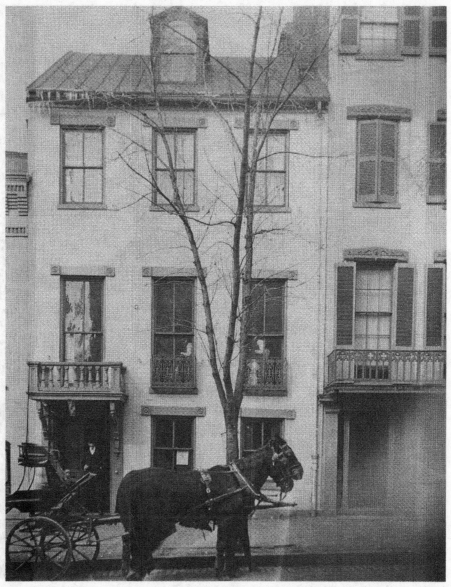

74. *Colored American*, a newspaper in Washington, D.C.

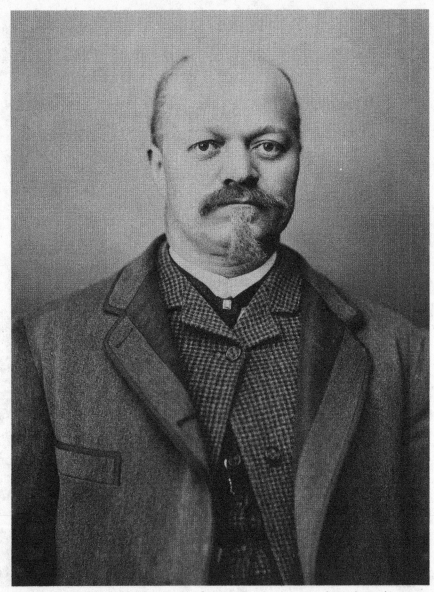

75. Warren C. Coleman, of Coleman Manufacturing Company, Concord, North Carolina.

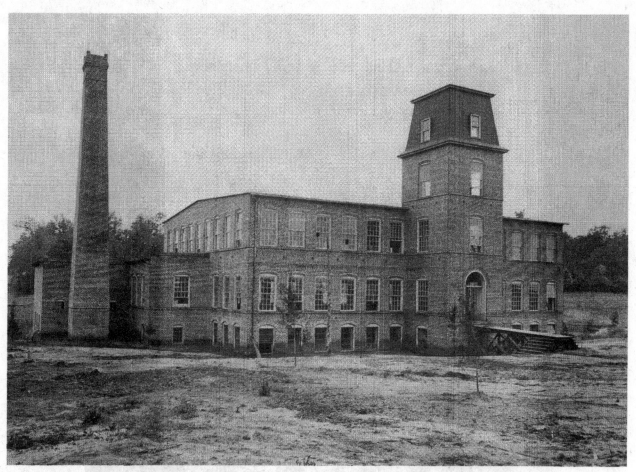

76. Coleman Manufacturing Company, a Negro-operated cotton mill, Concord, North Carolina; the only Negro-owned cotton mill in the United States at the time.

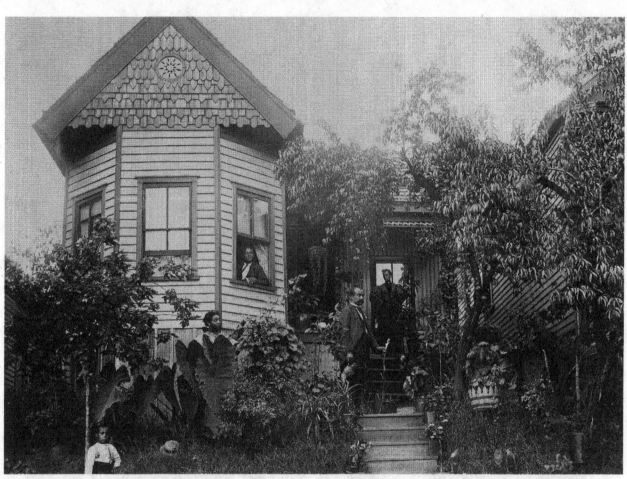

78. Home of C. C. Dodson, Knoxville, Tennessee.

OPPOSITE: 77. Mr. Dodson, jeweler in Knoxville, Tennessee.

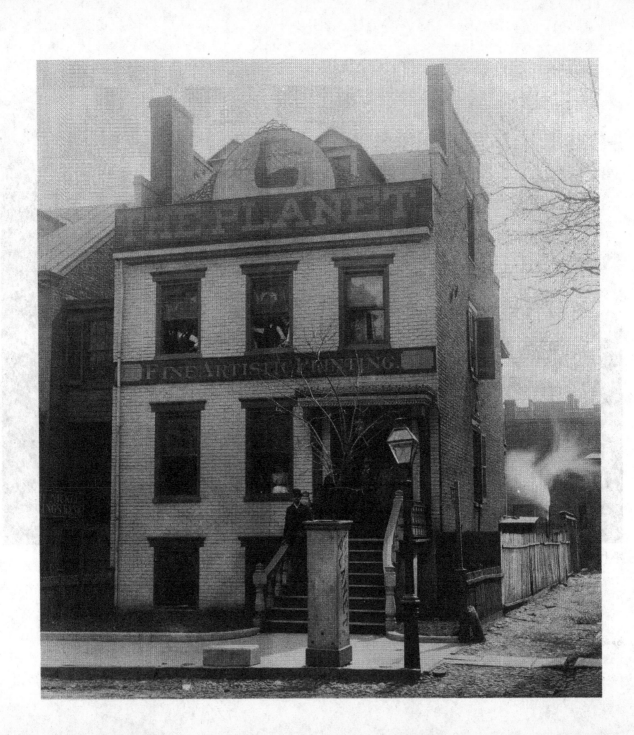

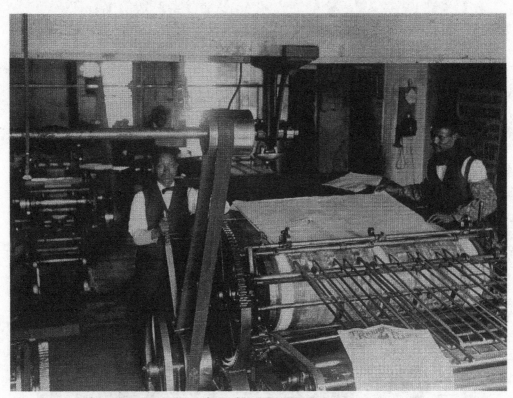

80. Press room of the *Planet* newspaper, Richmond, Virginia.

OPPOSITE: 79. The *Planet* newspaper, Richmond, Virginia.

81. The *Bee*, a newspaper in Washington, D.C.

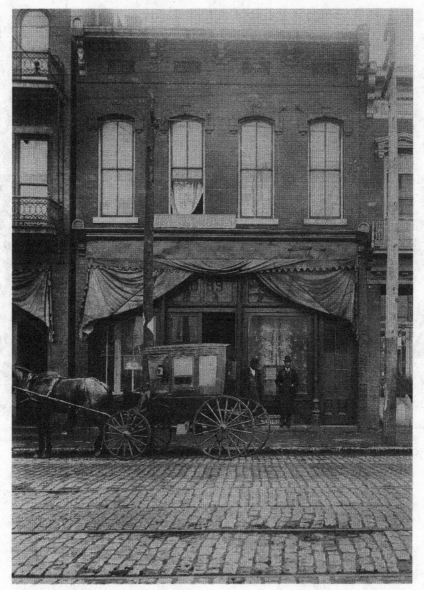

82. Union Hotel, Chattanooga, Tennessee.

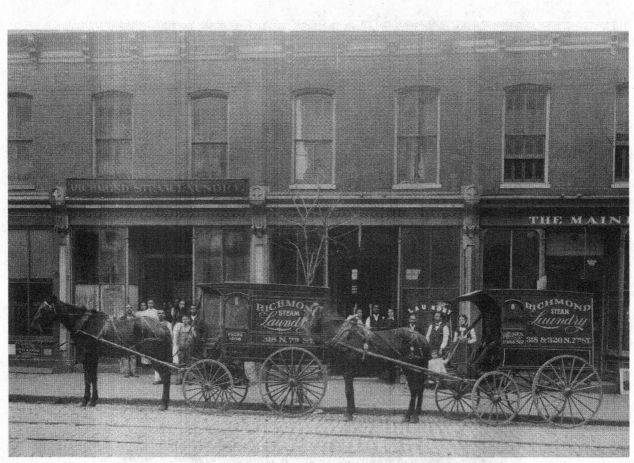

83. Richmond Steam Laundry, Richmond, Virginia.

84. E. J. Crane, watchmaker and jewelry store, Richmond, Virginia.

"Numbers of Negroes in business . . . 20,020

Among whom were agents and collectors . . . 1,172

Boarding House Keepers . . . 2,323

Druggists . . . 139

Hotel Keepers . . . 429

Watch and Clock Makers . . . 61

And more than 700 of these businesses had been

established more than thirty years."

—Colored American,

SEPTEMBER 22, 1900

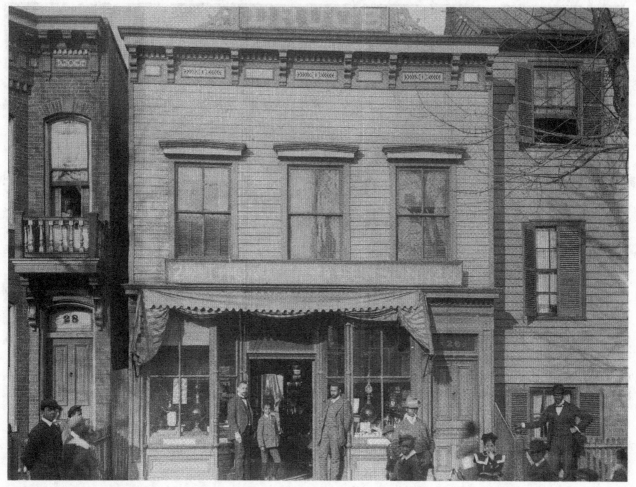

85. Leigh Street Pharmacy, Richmond, Virginia.

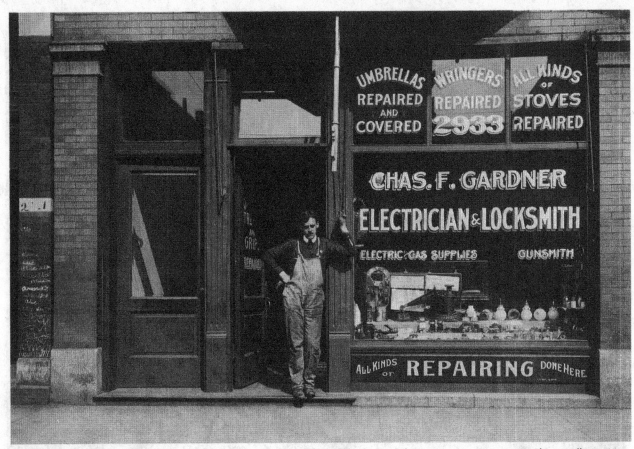

86 and 87 (*opposite*). Exterior and interior of the only Negro store of its kind in the United States, at 2933 State Street, Chicago, Illinois.

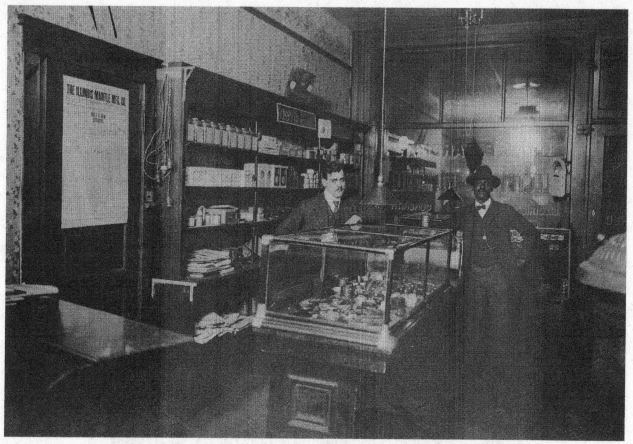

87.

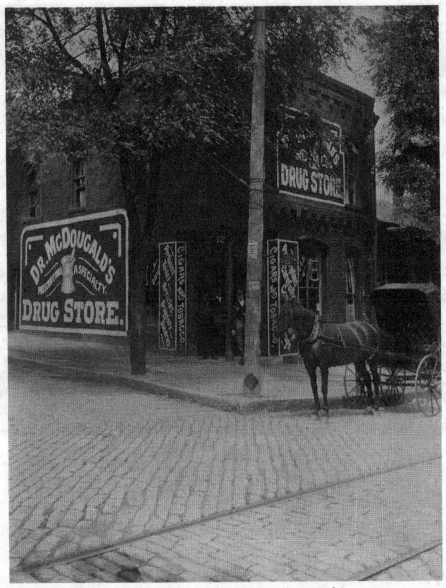

88 and 89 (opposite). Dr. McDougald's Drug Store, Georgia, with a view of the interior .

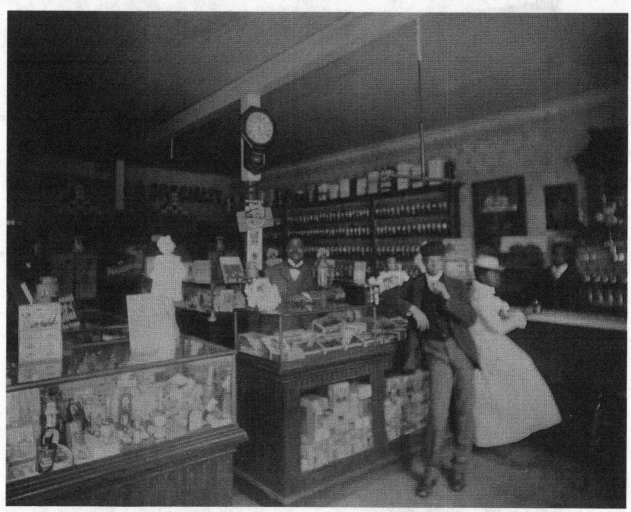

89.

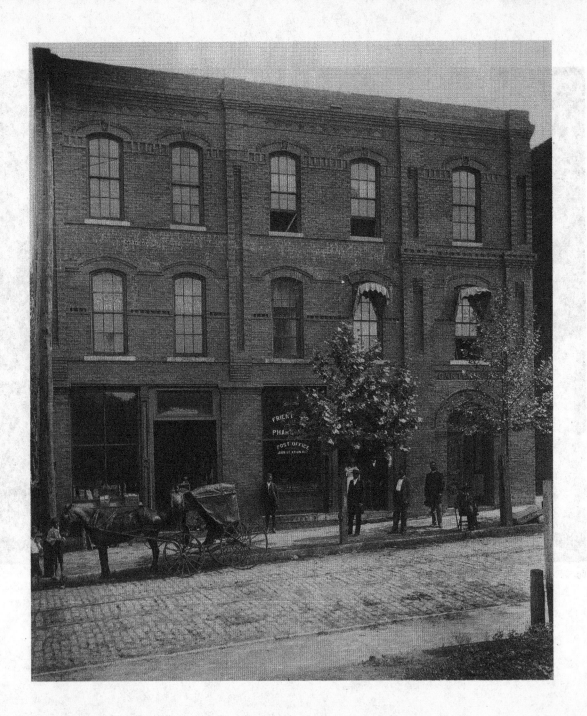

91. Funeral home of C. W. Franklin, undertaker, Chattanooga, Tennessee.

OPPOSITE: 90. Friendship Pharmacy and Post Office, Georgia.

92. Standard Ice wagon, Georgia.

93. African American man seated at desk in office, Georgia.

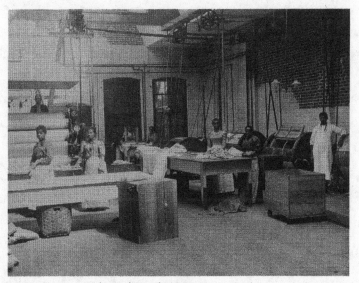

94. Lexington Laundry, Richmond, Virginia.

"Before the pilgrims landed we were here.

Here we have brought our three gifts and mingled them with yours:

a gift of story and song... the gift of sweat and brawn

to beat back the wilderness... the third, a gift of the spirit.

Around us the history of the land has centered

for thrice a hundred years."

—W. E. B. DU BOIS,

The Souls of Black Folk, 1903

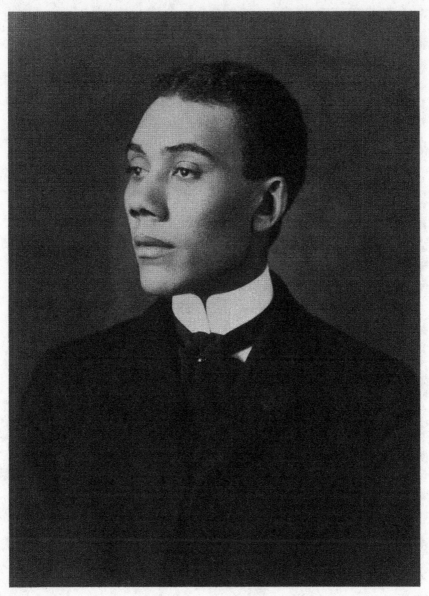

95.

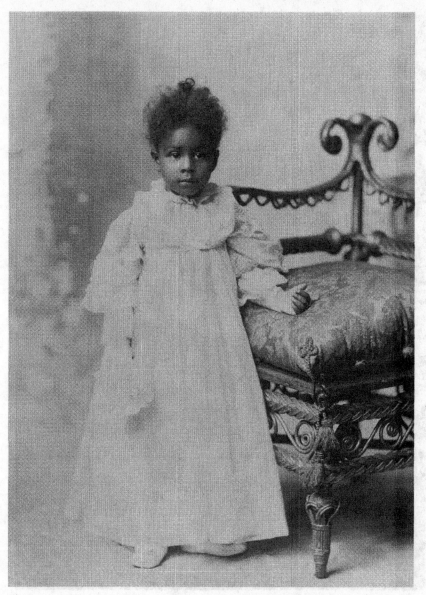

96.

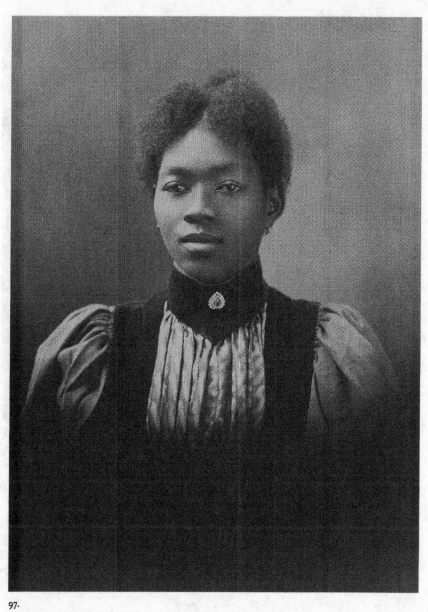

97.

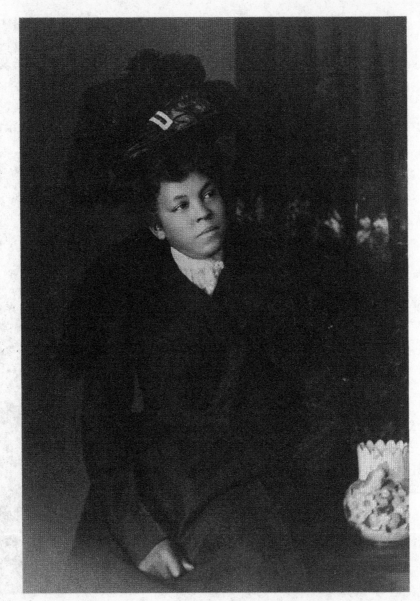

98.

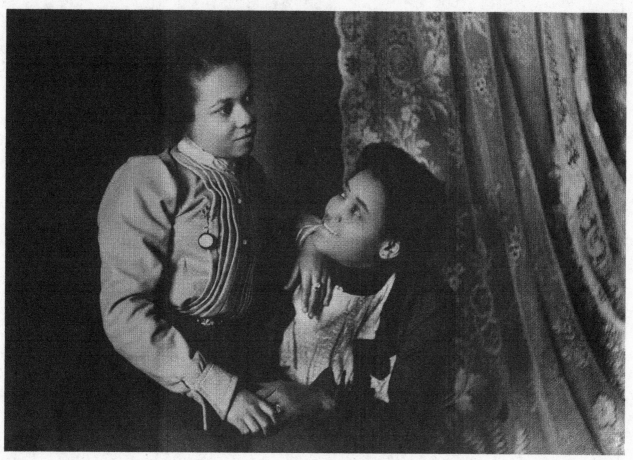

99.

100.

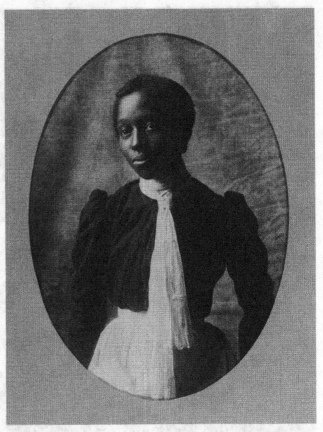

101.

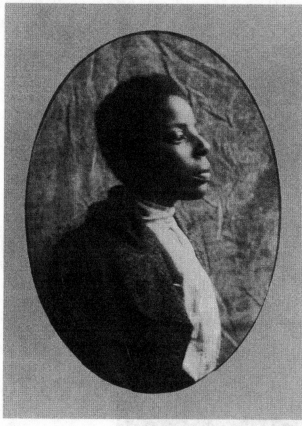

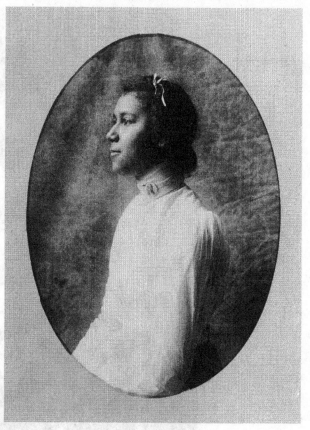

102.

103.

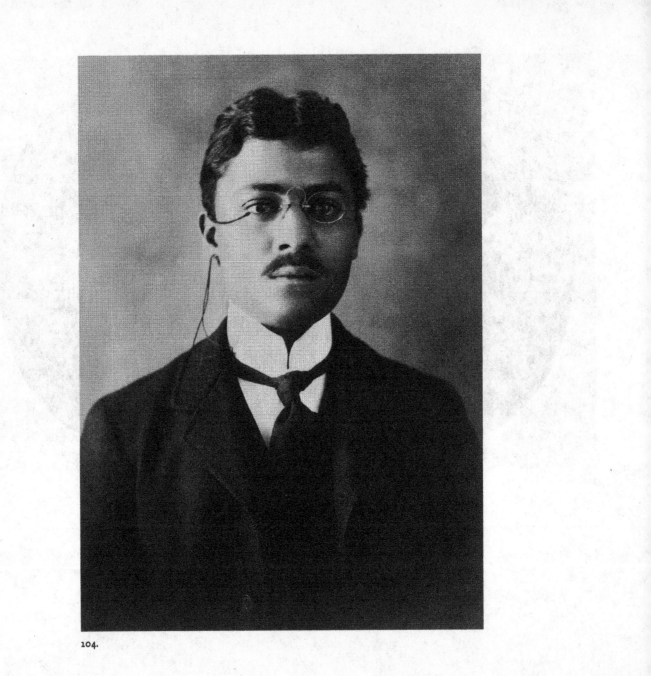

104.

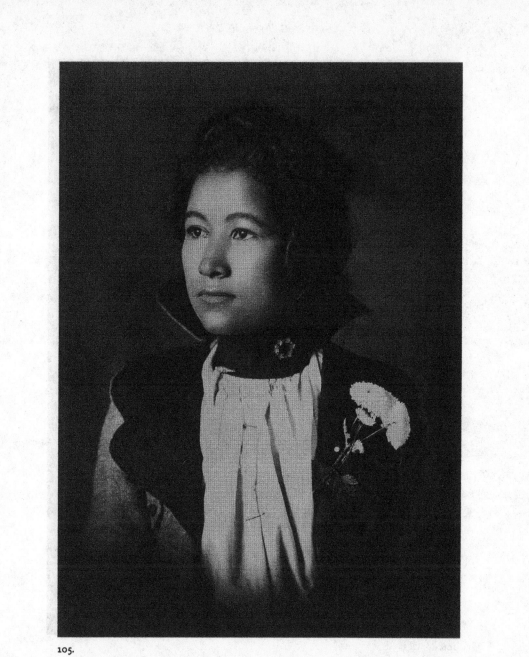

105.

106.

107.

108.

"Now and again we come to churches.
Here is one now.... It is the center of
a hundred cabin homes; and sometimes, of a Sunday,
five hundred persons from far and near
gather here and talk and eat and sing."

—W. E. B. DU BOIS,
The Souls of Black Folk, 1903

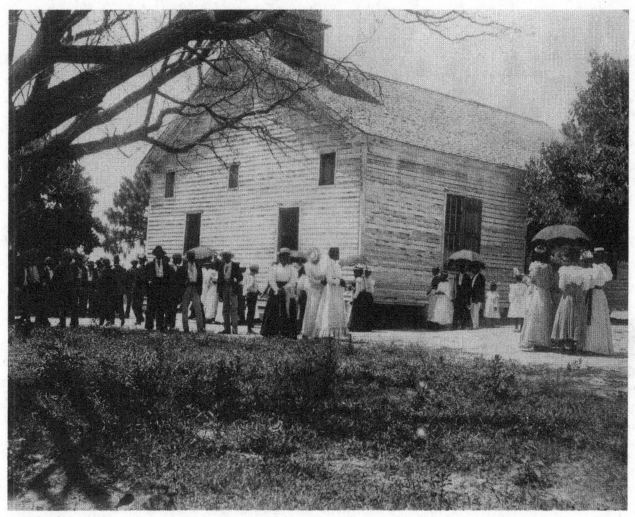

109. Church, Georgia.

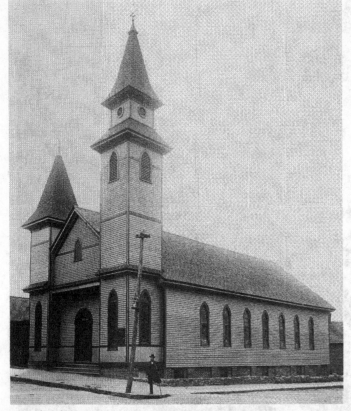

110. Church, Georgia.

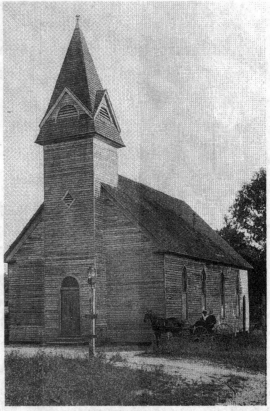

111. Wooden church, Georgia.

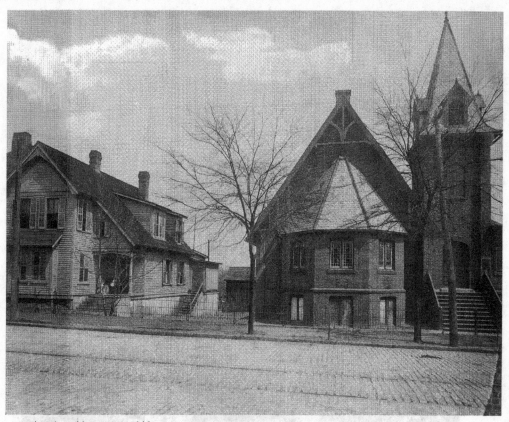

112. Church and house on cobblestone street, Georgia.

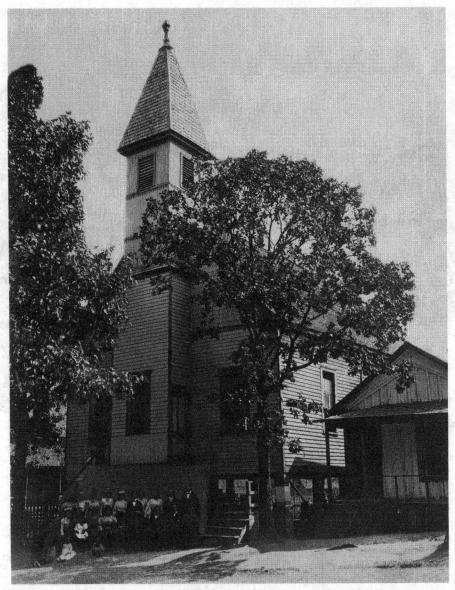

113. Men, women, and children outside church, Georgia.

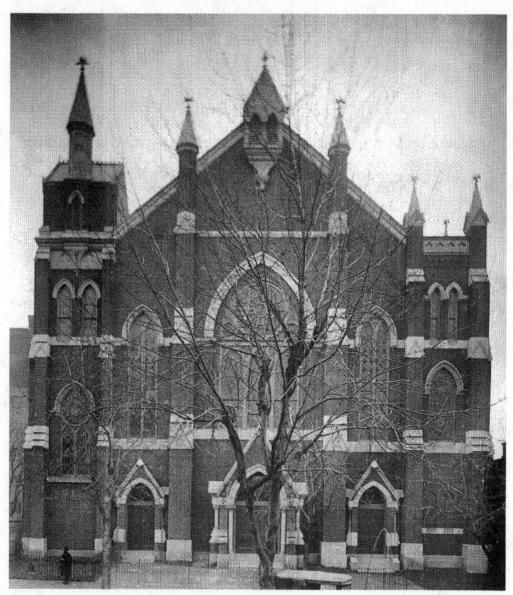

114. African Methodist Episcopal Church, Washington, D.C.

"The land is still fertile....

For nine and ten months in succession the crops will come if asked;

garden vegetables in April, grain in May,

melons in June and July, hay in August,

sweet potatoes in September, and cotton from then to Christmas."

—W. E. B. DU BOIS,

"The Negro As He Really Is,"

JUNE 1903

115. Three women and a man hoeing a field, Georgia.

116. Unpaved street between houses, Georgia.

117. Children feeding chickens, Georgia.

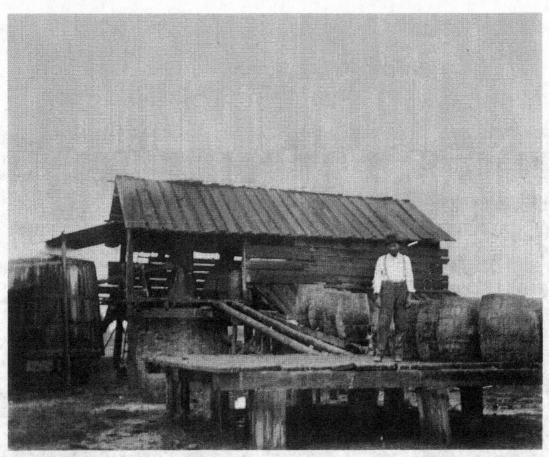

118. Man on platform or loading dock, Georgia.

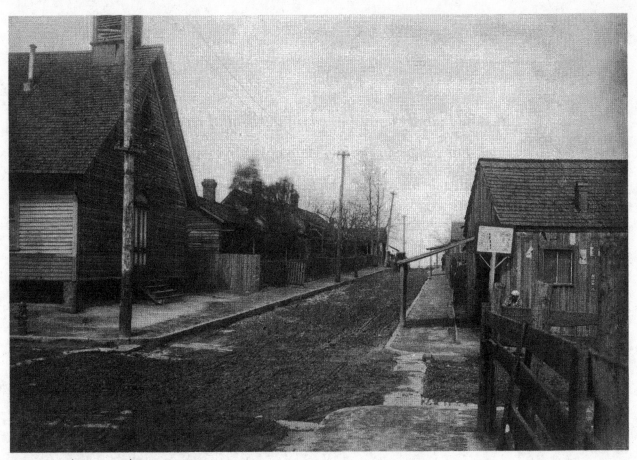

119. Houses along unpaved street, Georgia.

"It would hardly be suggested, in the light of recent history,

that conditions in the State of Georgia are such

as to give a rose-colored picture of the Negro; and yet . . .

they own 1,000,000 acres of land

and pay taxes on $12,000,000 worth of property."

—W. E. B. DU BOIS,

"The American Negro at Paris,"

NOVEMBER 1900

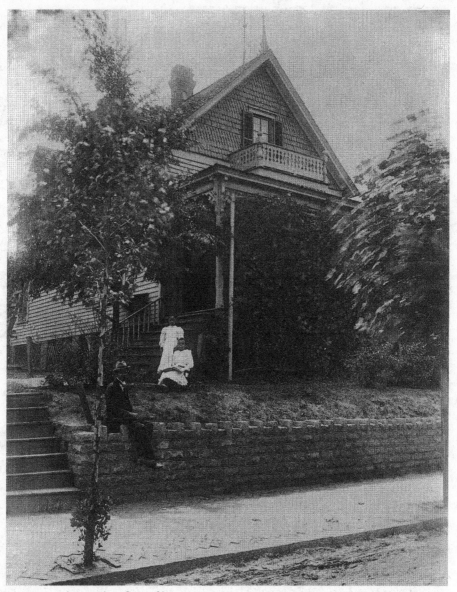

120. Man and two girls in front of house, Georgia.

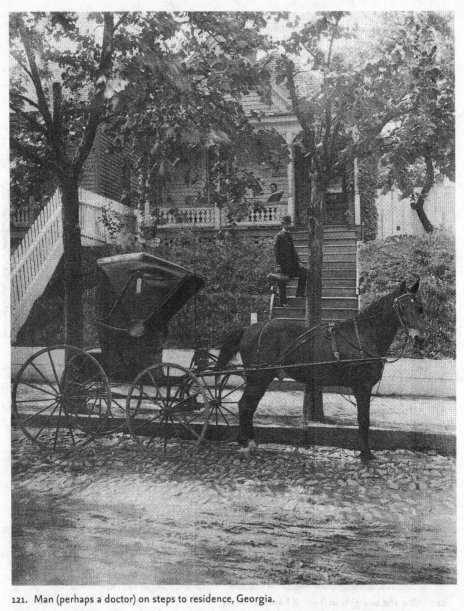

121. Man (perhaps a doctor) on steps to residence, Georgia.

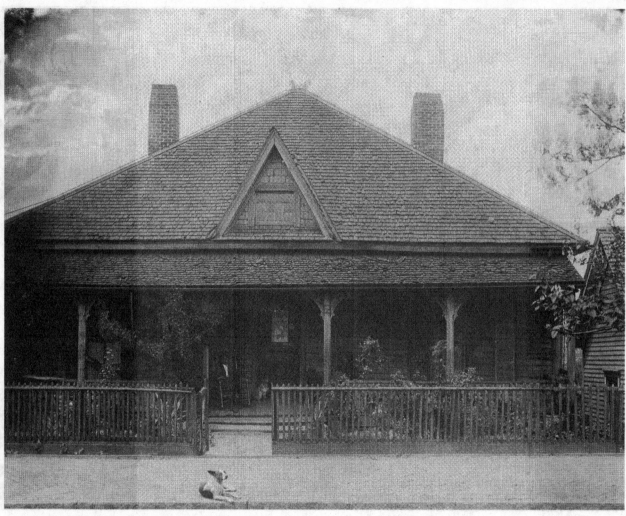

122. House with picket fence, dog on sidewalk, Georgia.

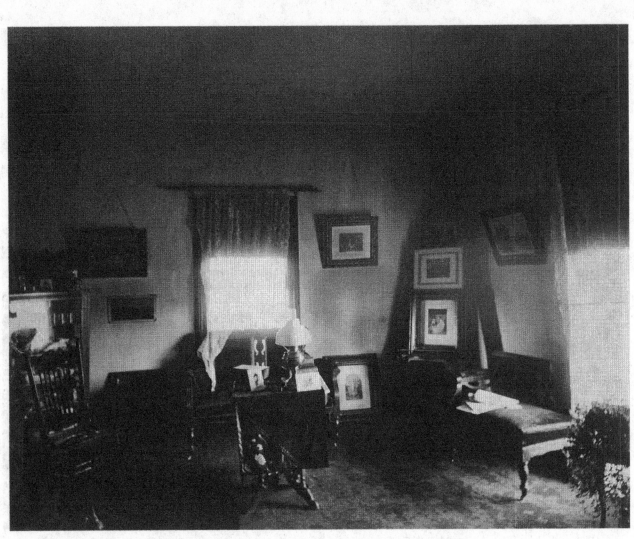

123. Interior with furniture and framed pictures, Georgia.

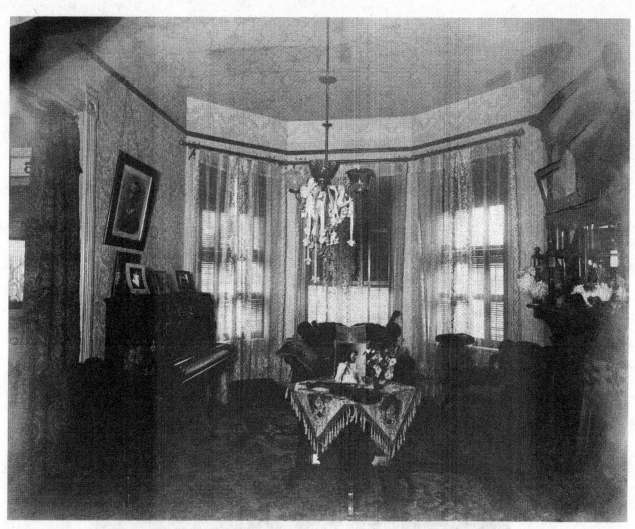

124. Interior with furniture, piano, and chandelier, Georgia.

125. Three people on porch, Georgia.

126. Family on porch, Georgia.

127. Two houses, boy, women, and boy with bicycle, Georgia.

128. Two children sitting on porch steps, Georgia.

"How beautiful he was, with his olive-tinted flesh
and dark gold ringlets, his eyes of mingled blue and brown,
his perfect little limbs, and the soft voluptuous roll
which the blood of Africa had molded into his features."

—W. E. B. DU BOIS,
The Souls of Black Folk, 1903

129.

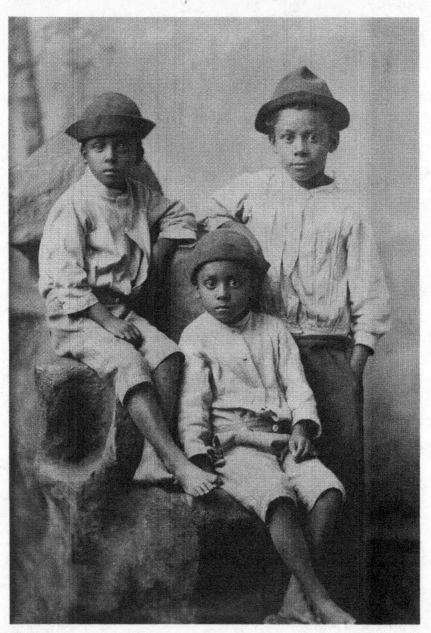

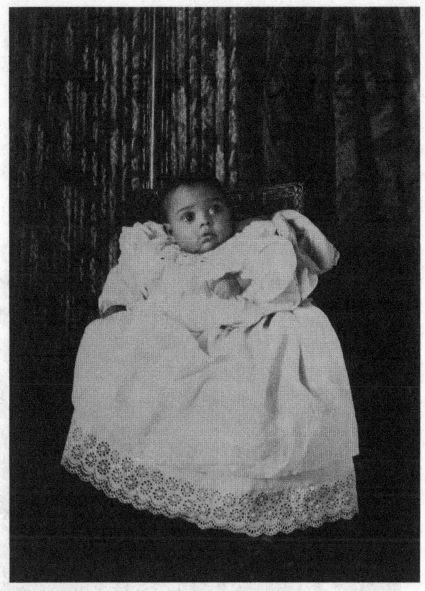

131.

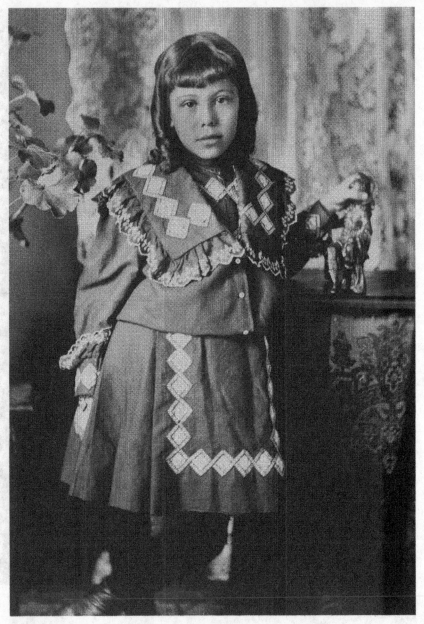

132.

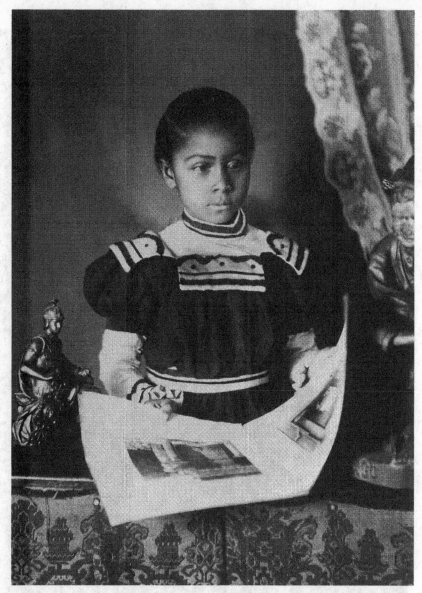

133.

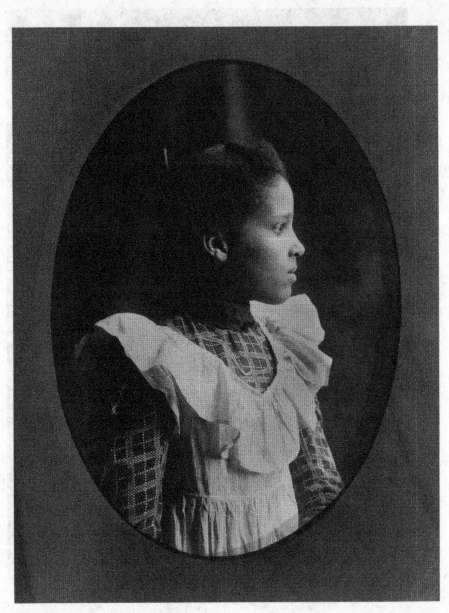

134.

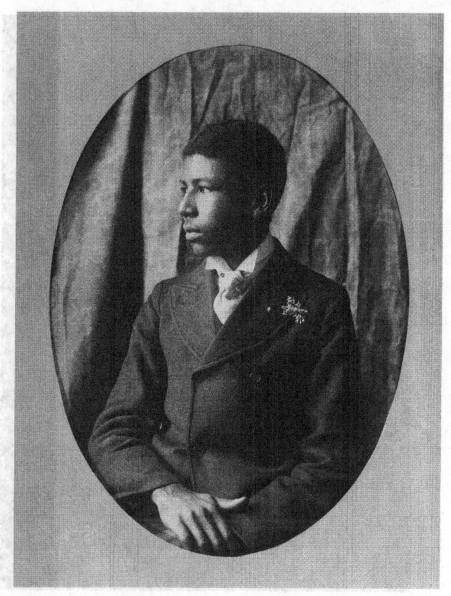

135.

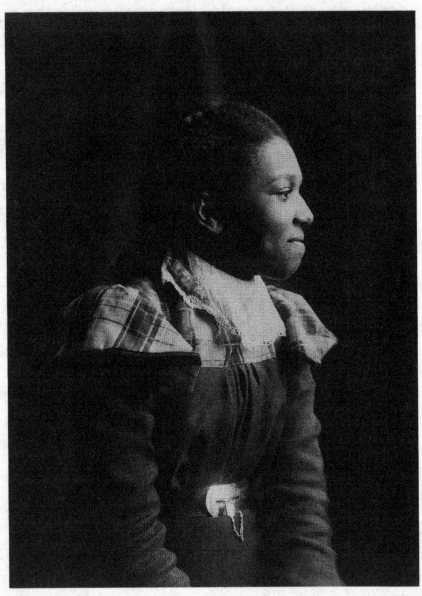

136.

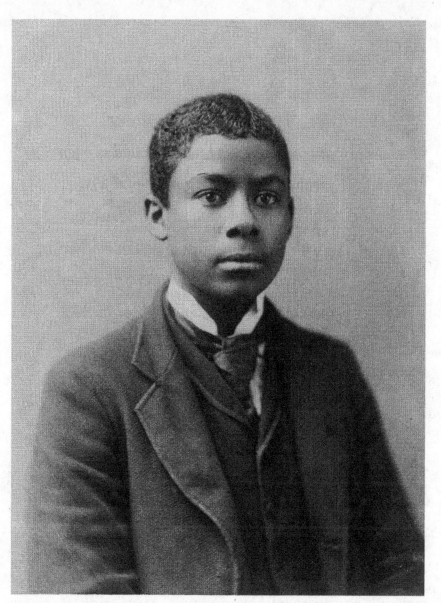

137.

"I cannot hesitate in saying
that nowhere have I met men and women
with a broader spirit of helpfulness,
with deeper devotion to their lifework,
or with more consecrated determination
to succeed in the face of bitter difficulties
than among Negro college-bred men."

—W. E. B. DU BOIS,
The Souls of Black Folk, 1903

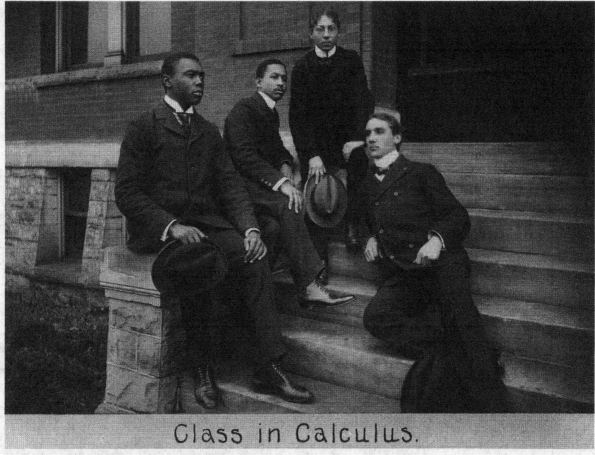

Class in Calculus.

138. Class in calculus, Fisk University, Nashville, Tennessee.

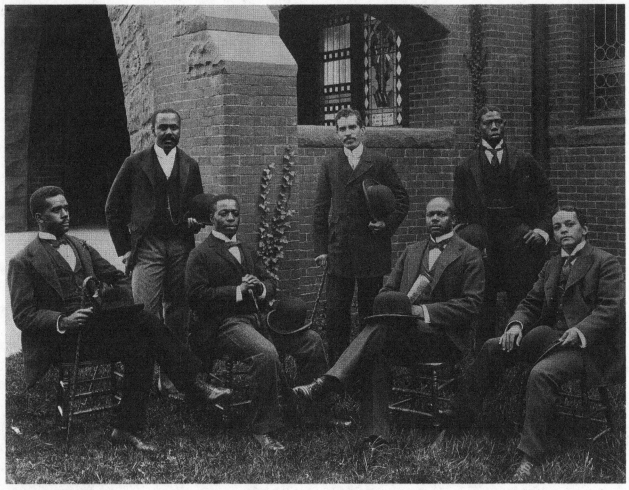

139. Class picture, circa 1900, Howard University, Washington, D.C.

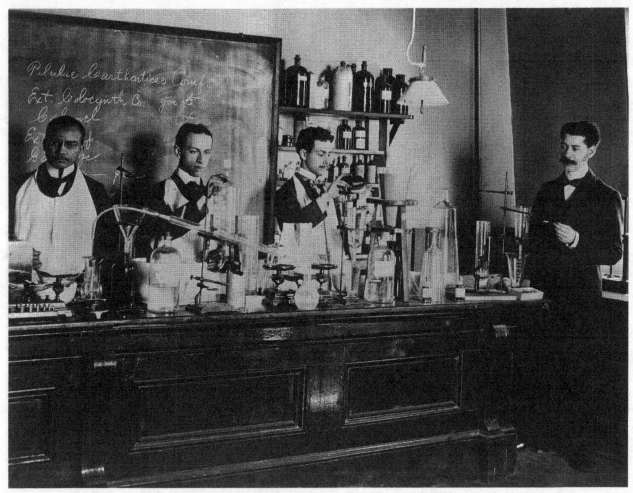

140. Pharmaceutical laboratory, Howard University, Washington, D.C.

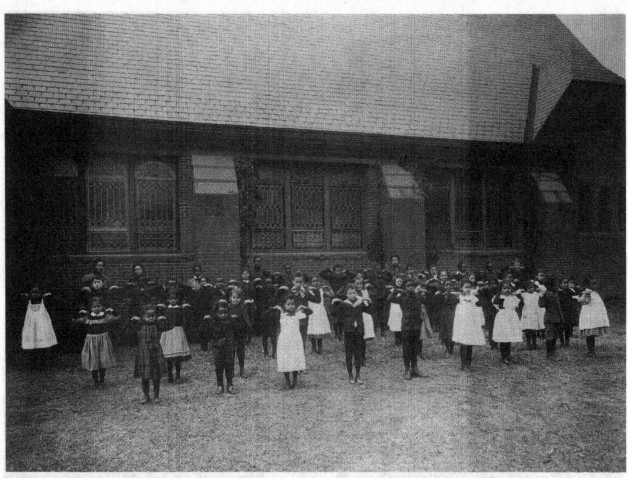
141. Practice school at Howard University, Washington, D.C.

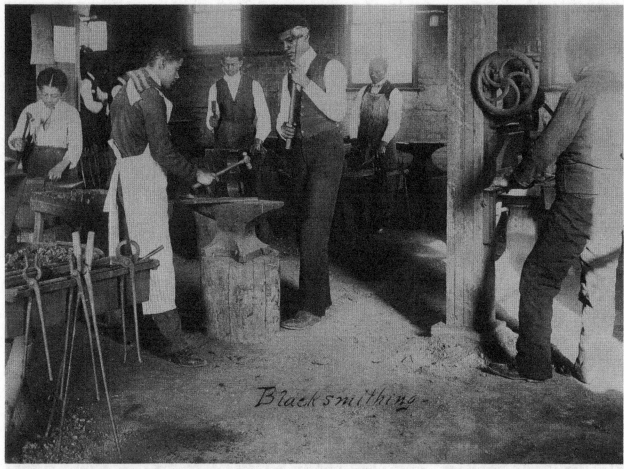

Blacksmithing

142. Blacksmithing, Agricultural and Mechanical College, Greensboro, North Carolina.

Model Dining-Room -

143. Model dining room, Agricultural and Mechanical College, Greensboro, North Carolina.

Cutting and Fitting

144. Cutting and fitting class, Agricultural and Mechanical College, Greensboro, North Carolina.

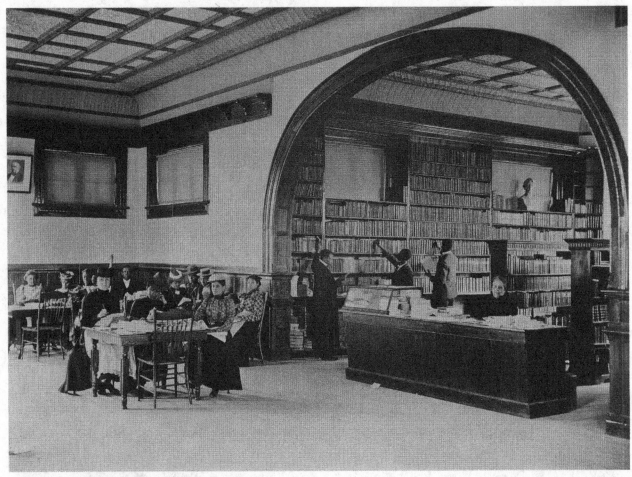

145. Library, Claflin University, Orangeburg, South Carolina.

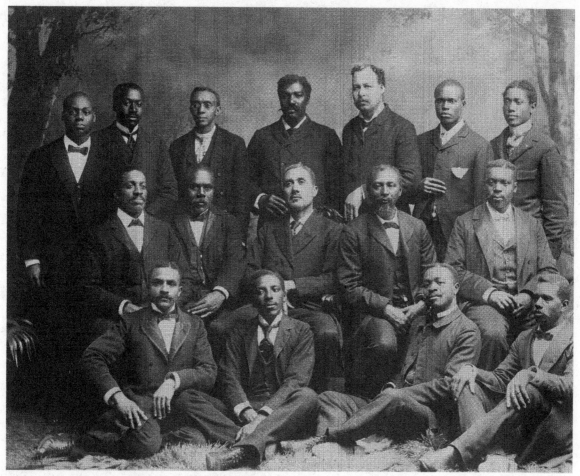

146. Ministers class, Roger Williams University, Nashville, Tennessee.

"There must come a loftier respect
for the sovereign human soul that seeks to know itself
and the world about it; that seeks a freedom
for expansion and self-development;
that will love and hate and labor in its own way,
untrammeled alike by old and new.
Such souls aforetime have inspired and guided worlds."

—W. E. B. DU BOIS,
The Souls of Black Folk, 1903

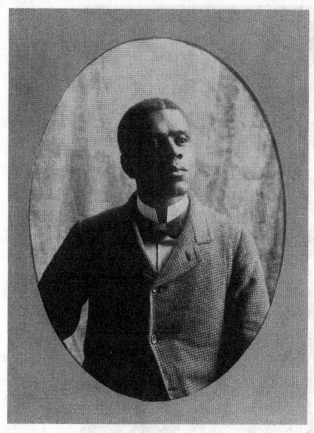

147.

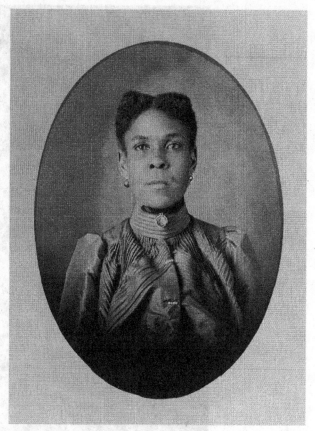

148.

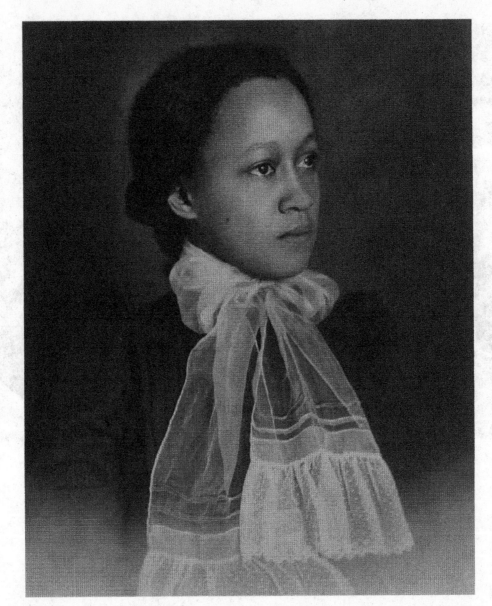

149.

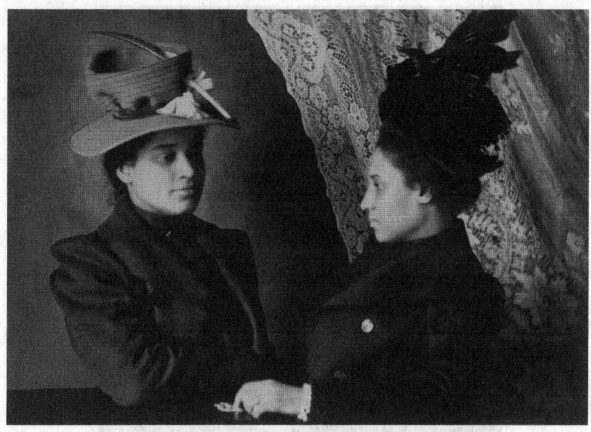

150.

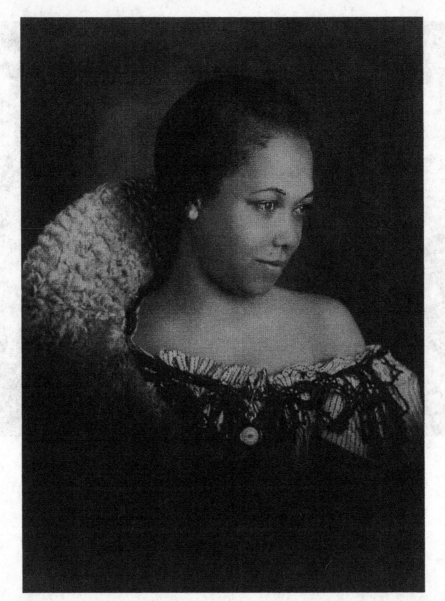

151.

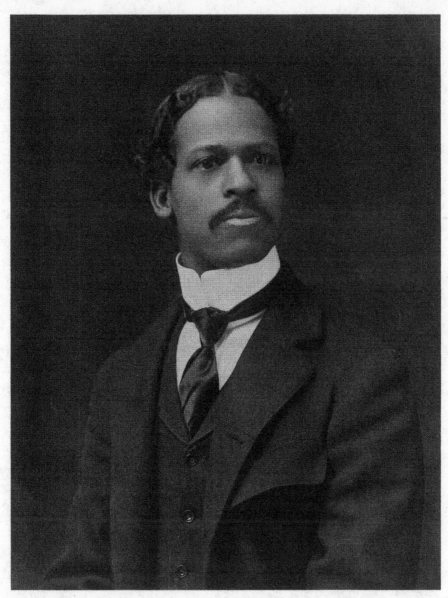

152.

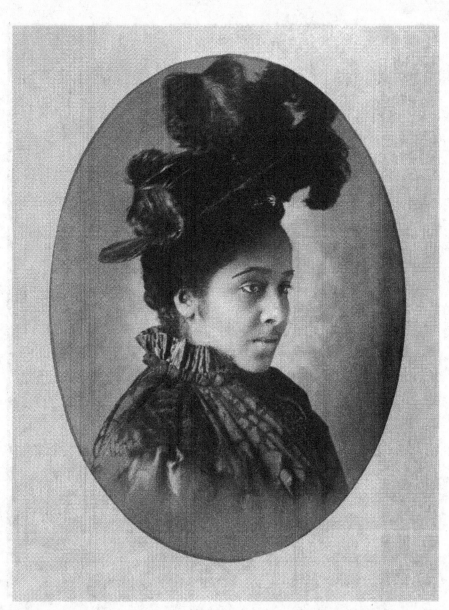

153.

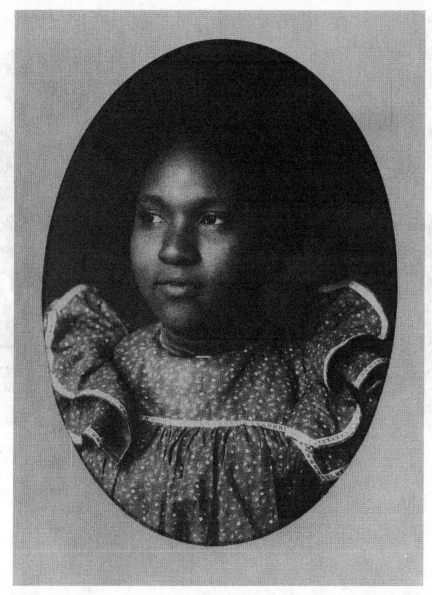

154.

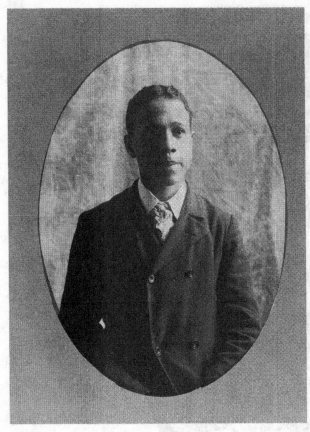

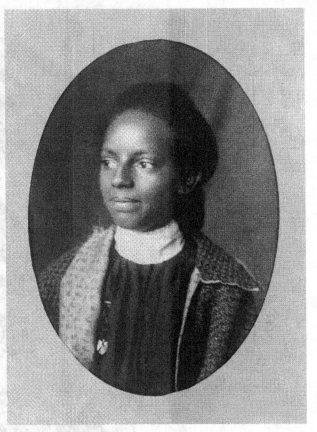

155.

156.

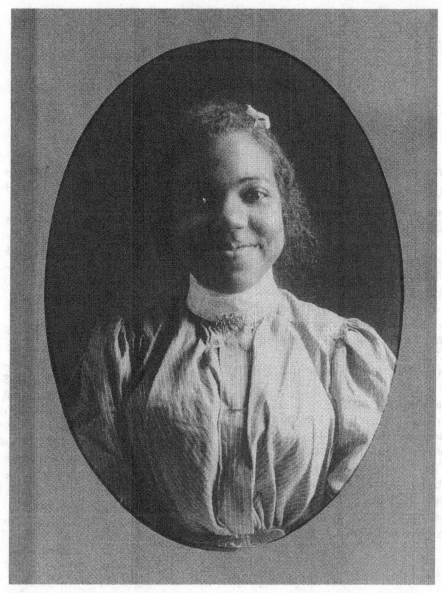

NOTES

A SMALL NATION OF PEOPLE *by David Levering Lewis*

1. "Du Bois Sailed This Week for Paris," *Colored American*, 21 July 1900, p. 6. "nervous prostration" quoted in *The Autobiography of W. E. B. Du Bois* ([New York]: International Publishers, 1968), 221.
2. On T. J. Calloway and W. E. B. Du Bois, see David Levering Lewis, *W. E. B. Du Bois: Biography of a Race, 1868–1919* (New York: Henry Holt, 1993), chap. 4. *Who's Who in Colored America*, 6th ed. (New York: Who's Who in Colored America Corp., 1941–1944), s.v. Calloway, Thomas Junius.
3. W. E. B. Du Bois, *The Souls of Black Folk* (1903; reprint, Millwood, N.Y.: Kraus-Thomson, 1973), 38.
4. "The Signs of the Times," *Colored American*, Nov. 24, 1900, p. 8.
5. Du Bois, *Souls*, 3–4.
6. Letter sent by T. J. Calloway, 4 October 1899, *The Booker T. Washington Papers*, eds. Louis Harlan and Raymond W. Smock (Urbana: University of Illinois Press, 1976), 5:226–27.
7. H.J. Res. 75, 56th Congress, 1st Session, 13 December 1899. Calloway to Booker T. Washington, 25 January 1900, *B. T. Washington Papers*, 5:227(n).
8. Rayford W. Logan and Michael R. Winston, eds., *Dictionary of American Negro Biography* (New York: W. W. Norton, 1982), s.v. Hilyer, Andrew F. See also Hilyer reference in *The Autobiographical Writings*, ed. Louis Harlan, vol. 1 of *B. T. Washington Papers* (1972), 184–85.
9. W. E. B. Du Bois, "The American Negro at Paris," *American Monthly Review of Reviews* 22 (November 1900), reproduced in *Writings by W. E. B. Du Bois in Periodicals Edited by Others*, ed. Herbert Aptheker (Millwood, N.Y.: Kraus Thompson, 1982), 1:86–88.
10. Ibid., 88.
11. Ibid.
12. The rise of Jim Crow laws, the decline in rights for African Americans, and Booker T. Washington's role are discussed in Lewis, *Du Bois: Biography of a Race*, chap. 10. Vardaman quoted, ibid., 261. W. E. B. Du Bois to S. H. Hardwick [assistant general passenger agent], 5 March 1900, ed. Herbert Aptheker, *The Correspondence of W. E. B. Du Bois* ([Amherst]: University of Massachusetts Press, 1973), 1:45–46. Du Bois to B. T. Washington, 16 March 1900, *B. T. Washington Papers*, 5:464. See also Lewis, *Du Bois: Biography of a Race*, 1:243-45.
13. "small nation of people," quoted in "The American Negro at Paris," p. 88. Theodore Stanton, "Open Letters," *The Century Magazine* (December 1895), p. 317.
14. B. D. Woodward, "The Exposition of 1900," *The North American Review* (April 1900), p. 476.

15. "ascend with it," ibid. "Georgia Paris Commissioner Leaves for the Big Exposition, *Atlanta Journal*, 1 June 1900, p. 5. "Arctic Section at the Exhibition Opens," *New York Herald*, 12 May 1900, p. 1.

16. Careful description of the Negro Exhibition as well as the general organization of the Palace of Social Economy in W. H. Tolman, "Social Economics in the Paris Exposition," *The Outlook* 6 (October 1900), pp. 312–15.

17. Ibid., 313.

18. "The Negro Exhibit at Paris," *Colored American*, 15 September 1900, p. 6.

19. "The Negro Exhibit at Paris," *Colored American*, 3 November 1900, p. 8. Du Bois quote, "The American Negro at Paris," p. 89(n).

20. "Colored Americans Dine," *Colored American*, 25 August 1900, p. 3. "American Negroes Dine, *New York Herald*, 8 August 1900, p. 1.

21. "The Negro Exhibit at Paris," *Colored American*, 3 November 1900, p. 8.

22. "The Distribution of Prizes," *New York Herald*, 20 August 1900, p. 2.

23. U.S. Commission to the Paris Exposition. *Report of The Commissioner-General for the United States to the International Universal Exposition, Paris, 1900*, Vol. 2 (Washington, D.C.: GPO, 1901), 408–9.

24. Du Bois, *Souls*, 13. On the rise of white supremacy, see Matthew Guterl, *The Color of Race in America, 1900–1940* (Cambridge: Harvard University Press, 2001); Joel Williamson, *The Crucible of Race* (New York: Oxford University Press, 1984); C. Vann Woodward, *The Strange Career of Jim Crow* (New York: Oxford University Press, 1955); Alexander Saxton, *The Rise and Fall of the White Republic* (New York: Verso, 1990).

THE SOCIOLOGIST'S EYE *by Deborah Willis*

1. "Opinion of W. E. B. Du Bois," *Crisis*, October 1923, p. 249.

2. Douglas Daniels, *Pioneer Urbanites* (Philadelphia: Temple University Press), 123.

3. Ibid., 126.

4. "Is He a New Negro?" *Chicago Inter Ocean*, in *The Booker T. Washington Papers*, ed. Louis R. Harlan, et al. (Urbana: University of Illinois Press, 1975), 4:34.

5. Harvey S. Teal, *Partners with the Sun: South Carolina Photographers, 1840–1940* (Columbia: University of South Carolina Press, 2001), 273.

6. Alan Trachtenberg, *Reading American Photographs: Images As History, Mathew Brady to Walker Evans* (New York: Noonday, 1989), xvi.

7. *The Autobiography of W. E. B. Du Bois* (New York: International Publishers: 1968 [1991 edition]), 221.

8. Paul Nadar, who had taken over the new studio in rue d'Anjou from his father, specialized in portraits of actors and actresses. *A New History of Photography*, ed. Michel Frizot (Paris: Konemann, 1998), 122.

9. Donald L. Grant, *The Way It Was in the South: The Black Experience in Georgia* (Athens: University of Georgia Press, 1993), 205.

10. Shawn Michelle Smith, *American Archives: Gender, Race, and Class in Visual Culture* (Princeton: Princeton University Press, 1999), 161.

11. Joan Severa, *Dressed for the Photographer: Ordinary Americans & Fashion, 1840–1900* (Kent, Ohio: Kent State University Press, 1995), 474.

12. Ibid., 443.

13. Joanne Entwistle, *The Fashioned Body* (Cambridge: Polity Press, 2000), 113.

14. Hazel Carby, *Race Men* (Cambridge: Harvard University Press, 1998), 21.
15. H. C. McEwen, "First Congregational Church, Atlanta: 'For the Good of Man and the Glory of God,'" *Atlanta Historical Bulletin Bulletin* 21, no. 1 (spring 1977): 129–42.
16. Thomas Calloway, "The Negro Exhibit," in U.S. Commission to the Paris Exposition, Report of the Commissioner-General for the United States to the International Universal Exposition, Paris, 1900, Vol. 2 (Washington, D.C.: Government Printing Office, 1901).

17. Ibid., 464.
18. Ibid., 464, 465.
19. Thomas Calloway to F. B. Johnston, May 15, 1900. Frances Benjamin Johnston Papers, Manuscript Division, Library of Congress.
20. "Harry Shepherd the Photographer," *St. Paul Appeal*, 3 February 1900, p. 3.
21. "Harry Shepherd," *Minneapolis Afro-American Advance*, 3 March 1900, p. 2.
22. "Harry Shepherd," *St. Paul Appeal*, 10 March 1900, p. 2.

ABOUT THE PHOTOGRAPHS

All the images the Library of Congress holds from the 1900 Paris Exposition may be viewed on the Library's Internet site (www.loc.gov), in the Prints and Photographs Online Catalog in the collection designated "African American Photographs Assembled for the 1900 Paris Exposition." The following list provides reproduction numbers for images available from the Prints and Photographs Division of the Library of Congress. Prints of illustrations with reproduction numbers may be ordered directly from the Library's Photoduplication Service, Washington, D.C. 20540-5230 (telephone: 202-707-5640). Information about the Library's Photoduplication Service also may be accessed at the Library's Internet address.

Grateful acknowledgment is made for permission to reproduce the following plates:

7, 17, 20, 21 courtesy of Special Collections and Archives, W. E. B. Du Bois Library, University of Massachusetts, Amherst.

8 courtesy of the Daniel A. P. Murray Association at the Library of Congress.

Plate 2 is from *Peerless Paris and Its Marvelous Universal Exposition*, published 1900.

Plate 4 is from *Paris and the Exposition: Original Photographs and Sketches by Our Special Artists Graphically Described*, published 1900.

Other Collections and Publications Relevant to the 1900 Paris Exposition

The Library of Congress Manuscript Division holds several volumes of the statistics W. E. B. Du Bois compiled for the Georgia Exhibit, as part of the Daniel A. P. Murray Collection. The Rare Books and Special Collections Division houses Murray's collection of written works by African Americans.

W. E. B. Du Bois, "The American Negro in Paris," in the *American Monthly Review of Reviews*, November 1900.

Thomas Calloway, "The Negro Exhibit," in the *Report of the Commissioner-General for the United States to the International Universal Exposition, Paris 1900*, published by the Government Printing Office, Washington, D.C., in 1901.

The Colored American, November 3, 1900. Available on microfilm.

"Paris 1900: The Exhibit of American Negroes," a website created by Dr. Eugene Provenzo of the University of Miami. Dr. Provenzo has also reconstructed highlights of the exhibit for *The African-American Multimedia Collection*, a CD-ROM produced by Facts on File.

Library of Congress Image Descriptions and LC Reproduction Numbers

Page 1: Detail of plate 97. African American woman, head-and-shoulders portrait, facing slightly left (LC-USZ62-124652).

1 Frontispiece: African American man giving a piano lesson to young African American woman, Georgia (LC-USZ62-63575).

OTHER SELECTIONS FROM THE PHOTOGRAPHS
AT THE EXPOSITION DES NÈGRES D'AMÉRIQUE,
"EXPOSITION OF AMERICAN NEGROES"

40 African American man, head-and-shoulders portrait, facing right (LC-USZ62-124801).

41 African American woman, half-length portrait, facing front (LC-USZ62-124736).

42 African American woman, half-length portrait, right profile (LC-USZ62-124731).

43 African American man, half-length portrait, left profile (LC-USZ62-124742).

44 African American man, head-and-shoulders portrait, facing slightly right (LC-USZ62-124806).

45 African American woman, half-length portrait, facing right (LC-USZ62-124752).

46 African American woman, half-length portrait, facing left (LC-USZ62-124711).

47 African American man, head-and-shoulders portrait, facing left (LC-USZ62-124799).

48 African American boy, three-quarter-length portrait, half-sitting on table, facing front (LC-USZ62-124803).

49 African American woman, head-and-shoulders portrait, facing slightly left (LC-USZ62-124648).

50 African American girl, head-and-shoulders portrait, facing right (LC-USZ62-124675).

51 African American man, head-and-shoulders portrait, facing front (LC-USZ62-124651).

52 African American man, head-and-shoulders portrait, facing slightly left (LC-USZ62-116617).

53 African American family seated on lawn, Georgia (LC-USZ62-69913).

54 African American band on steps, Georgia (LC-USZ62-69914).

55 Baseball players, Morris Brown College, Georgia (LC-USZ62-114266).

56 Waiters Union, Georgia (LC-USZ62-114263).

57 Carpenters Union, Jacksonville, Florida (LC-USZ62-35753).

58 Sisters of the Holy Family, New Orleans, Louisiana (LC-USZ62-53509).

59 S. J. Gilpin shoe store, Richmond, Virginia (LC-USZ62-99053).

60 African American children and adults in a pavilion, Georgia (LC-USZ62-69907).

61 Men and boys dressed for church, Georgia (LC-USZ62-124854).

62 Men and women on steps, Georgia (LC-USZ62-124916).

63 African American woman, half-length portrait, facing slightly left (LC-USZ62-124728).

64 African American man, head-and-shoulders portrait, facing front (LC-USZ62-124780).

65 African American woman, half-length portrait, left profile (LC-USZ62-124715).

66 African American woman, head-and-shoulders portrait, facing slightly right (LC-USZ62-124680).

67 African American woman, half-length portrait, facing front (LC-USZ62-124681).

68 African American woman, head-and-shoulders portrait, facing right (LC-USZ62-124679).

69 African American girl, head-and-shoulder portrait, left profile (LC-USZ62-124624).

70 African American woman, half-length portrait, facing right (LC-USZ62-124750).

71 African American man, half-length portrait, left profile (LC-USZ62-124704).

72 African American woman, half-length portrait, facing right, with left hand under chin (LC-USZ62-117947).

73 African American man, half-length portrait, seated, facing front (LC-USZ62-124665).

74 *Colored American*, a newspaper in Washington, D.C. (LC-USZ62-69309).

75 Warren C. Coleman, of Coleman Manufacturing Company, Concord, North Carolina (LC-USZ62-51071).

76 Coleman Manufacturing Company, Concord, North Carolina (LC-USZ62-51072).

77 Mr. Dodson, jeweler in Knoxville, Tennessee (LC-USZ62-53508).

78 Home of C. C. Dodson, Knoxville, Tennessee (LC-USZ62-49479).

79 The *Planet* newspaper, Richmond, Virginia (LC-USZ62-118032).

80 Press room of the *Planet* newspaper, Richmond, Virginia (LC-USZ62-99055).

81 The *Bee*, a newspaper in Washington, D.C. (LC-USZ62-51805).

82 Union Hotel, Chattanooga, Tennessee (LC-USZ62-72435).

83 Richmond Steam Laundry, Richmond, Virginia (LC-USZ62-99052).

84 E. J. Crane, watchmaker and jewelry store, Richmond, Virginia (LC-USZ62-118028).

85 Leigh Street Pharmacy, Richmond, Virginia (LC-USZ62-98451).

86 Only Negro store of its kind in the United States, at 2933 State Street, Chicago, Illinois (LC-USZ62-61736).

87 Interior, only Negro store of its kind in the United States, at 2933 State Street, Chicago, Illinois (LC-USZ62-72443).

88 Dr. McDougald's Drug Store, Georgia (LC-USZ62-76771).

89 Interior, Dr. McDougald's Drug Store, Georgia (LC-USZ62-69910).

90 Friendship Pharmacy and Post Office, Georgia (LC-USZ62-69904).

91 Funeral home of C. W. Franklin, undertaker, Chattanooga, Tennessee (LC-USZ62-109101).

92 Standard Ice wagon, Georgia (LC-USZ62-69909).

93 African American man seated at desk in office, Georgia (LC-USZ62-76770).

94 Lexington Laundry, Richmond, Virginia (LC-USZ62-118030).

95 African American man, head-and-shoulders portrait, facing left (LC-USZ62-124659).

96 African American girl, full-length portrait, standing next to chair, facing front (LC-USZ62-124805).

97 African American woman, head-and-shoulders portrait, facing slightly left (LC-USZ62-124652).

98 African American woman, three-quarter-length portrait, facing slightly right, wearing hat (LC-USZ62-124643).

99 Two African American women, three-quarter-length portrait, seated, facing each other (LC-USZ62-124650).

100 African American woman, half-length portrait, facing slightly right (LC-USZ62-124738).

101 African American woman, half-length portrait, facing left (LC-USZ62-124748).

102 African American woman, head-and shoulders portrait, right profile (LC-USZ62-124723).

103 African American woman, half-length portrait, left profile (LC-USZ62-124702).

104 African American man, head-and-shoulders portrait, facing front (LC-USZ62-124802).

105 African American woman, head-and-shoulders portrait, facing left (LC-USZ62-124685).

106 African American man, head-and-shoulders portrait, facing front (LC-USZ62-124670).

107 African American woman, half-length portrait, facing slightly right (LC-USZ62-124796).

108 African American man, half-length portrait, facing front (LC-USZ62-124647).

109 Church, Georgia (LC-USZ62-103393).

110 Church, Georgia (LC-USZ62-124917).

111 Wooden church, Georgia (LC-USZ62-124922).

112 Church and house on cobblestone street, Georgia (LC-USZ62-83629).

113 Men, women, and children outside church, Georgia (LC-USZ62-124913).

114 African Methodist Episcopal Church, Washington, D.C. (LC-USZ62-51949).

115 Three women and a man hoeing a field, Georgia (LC-USZ62-103813).

116 Unpaved street between houses, Georgia (LC-USZ62-124869).

117 Children feeding chickens, Georgia (LC-USZ62-124867).

118 Man on platform or loading dock, Georgia (LC-USZ62-124826).

119 Houses along unpaved street, Georgia (LC-USZ62-124899).

120 Man and two girls in front of house, Georgia (LC-USZ62-114270).

121 Man (perhaps a doctor) on steps to residence, Georgia (LC-USZ62-124914).

122 House with picket fence, dog on sidewalk, Georgia (LC-USZ62-124863).

123 Interior with furniture and framed pictures, Georgia (LC-USZ62-124865).

124 Interior with furniture, piano, and chandelier, Georgia (LC-USZ62-124864).

125 Three people on porch, Georgia (LC-USZ62-114516).

126 Family on porch, Georgia (LC-USZ62-124920).

127 Two houses, boy, women, and boy with bicycle, Georgia (LC-USZ62-114265).

128 Two children sitting on porch steps, Georgia (LC-USZ62-103812).

129 African American boy, full-length portrait, standing facing front, with left hand resting on table (LC-USZ62-63573).

130 Three African American boys, full-length portrait, facing front (LC-USZ62-69906).

131 African American baby, full-length portrait, wearing Christening gown (LC-USZ62-124653).

132 African American girl, full-length portrait, standing next to table, facing front (LC-USZ62-124808).

133 African American girl, half-length portrait, standing at table with illustrated book, facing slightly right (LC-USZ62-124804).

134 African American girl, half-length portrait, facing right (LC-USZ6-2234).

135 Young African American man, half-length portrait, seated, facing left (LC-USZ62-124720).

136 African American woman, half-length portrait, seated, right profile (LC-USZ62-124790).

137 Young African American man, half-length portrait, facing slightly right (LC-USZ62-124800).

138 Class in calculus, Fisk University, Nashville, Tennessee (LC-USZ62-91995).

139 Class picture, circa 1900, Howard University, Washington, D.C. (LC-USZ62-40470).

140 Pharmaceutical laboratory, Howard University, Washington, D.C. (LC-USZ62-35750).

141 Practice school at Howard University, Washington, D.C. (LC-USZ62-46480).

142 Blacksmithing, Agricultural and Mechanical College, Greensboro, North Carolina (LC-USZ62-71813).

143 Model dining room, Agricultural and Mechanical College, Greensboro, North Carolina (LC-USZ62-42092).

144 Cutting and fitting class, Agricultural and Mechanical College, Greensboro, North Carolina (LC-USZ62-118917).

145 Library, Claflin University, Orangeburg, South Carolina (LC-USZ62-8297).

146 Ministers class, Roger Williams University, Nashville, Tennessee (LC-USZ62-126753).

147 African American man, half-length portrait, facing slightly right (LC-USZ62-124707).

148 African American woman, half-length portrait, facing front (LC-USZ62-124646).

149 African American woman, half-length portrait, facing right (LC-USZ62-124814).

150 Two African American women, half-length portrait, facing each other (LC-USZ62-124695).

151 African American woman, head-and-shoulders portrait, facing right (LC-USZ62-124690).

152 African American man, half-length portrait, facing right (LC-USZ62-121113).

153 African American woman, head-and-shoulders portrait, wearing hat, facing right (LC-USZ62-124678).

154 African American woman, head-and-shoulders portrait, facing left (LC-USZ62-124637).

155 Young African American man, half-length portrait, facing front (LC-USZ62-124717).

156 African American woman, head-and-shoulders portrait, facing left (LC-USZ62-124767).

157 Young African American woman, half-length portrait, facing front, smiling (LC-USZ62-124612).

ACKNOWLEDGMENTS

Many people played a role in creating *A Small Nation of People*. At the Library of Congress, Maricia Battle, assistant curator in the Prints and Photographs Division, deserves many thanks for her efforts to bring the Paris Exposition photographs to the attention of the public and to conserve the original albums. She provided ready assistance and information during the preparation of this book, as did Carroll Johnson-Welsh, of the Interpretive Programs Office. Ms. Johnson-Welsh also played a major role in the display of some of these photographs as exhibition director for the Library's 1998 exhibit *The African American Odyssey*. This exhibit was curated by Debra Newman Ham and developed under the guidance of IPO director Irene Chambers. Adrienne Cannon, Afro-American history and culture specialist for the Manuscript Division, provided guidance for *The African American Odyssey* and has been a tremendous help in answering questions about Daniel Murray and Thomas Calloway, two organizers of the Paris Exposition.

As picture editor, Vincent Virga made invaluable contributions. He has a remarkable eye for selecting images and an insightful sensitivity to the stories photographs have to tell. Publishing Office intern Nicholas Osborne displayed an uncanny ability to sit for hours in front of a microfilm machine. His primary research, poring over hundreds of issues of newspapers, articles, legislative records, and letters provided a solid foundation for this work.

Clarke Allen, of the Publishing Office, generously provided a photograph of Daniel Murray, and Blaine Marshall contributed her excellent advice on photographs. Gloria Baskerville-Holmes was an unfailing source of thoughtful observations, support, and encouragement.

We would also like to thank Georgia Zola, Sandra Lawson, Barbara Oliver, Kia Campbell, Erica Kelly, Kenneth Johnson, and the photographers of the Library's Photoduplication Service for the extra efforts they made to ensure prompt reproduction of the photographs in this book.

The website on "Paris 1900: The Exhibit of American Negroes," created by Eugene Provenzo, a professor in the School of Education at the University of Miami, is an excellent, superbly organized overview of the American Negro Exhibit, as well as the work done by W. E. B. Du Bois. Dr. Provenzo also reconstructed highlights of the exhibit for *The African-American Multimedia Collection*, a CD-ROM produced by Facts on File.

Grateful thanks go to Deborah Willis and David Levering Lewis for the lively and informative essays that accompany and illuminate these photographs. Ms. Willis was greatly aided in her research by the staffs of the Atlanta University Library, the Auburn Avenue Research Center, and the Atlanta History Center, and by Herman "Skip" Mason Jr. at Digging It Up, Inc., in Atlanta, Georgia.

We are indebted to agent Martha Kaplan for her energy and enthusiasm, and to Darah Smith, editorial assistant at Amistad, a paragon of kindness and efficiency. Thanks also to designer Laura Lindgren, design manager Betty Lew, production manager Dianne Pinkowitz, and managing editor John Jusino for their contributions. Finally, the Library greatly appreciates the support, patience, and inspiring creative vision of Dawn Davis, editorial director of Amistad, without whom this book would not have been possible.